MARGINATED

*Seventeenth-Century Printed Books and
the Traces of Their Readers*

Like some made rich by robbing of the ir
Or that so fond I am of being Sire,
I'le father Bastards; or if need require
I'le tell a lye in Print to get applause.
I scorn it; *John* such dirt-heap never w
Since God converted him. Let this suffic
To shew why I my *Pilgrim* patronize.

It came from mine own heart, so to my
And thence into my fingers trickled,
Then to my Pen, from whence immediate
On Paper I did dribble it daintily.

Manner and matter too was all mine
Nor was it unto any mortal known,
'Till I had done it. Nor did any then
By Books, by wits, by tongnes, or pen,
Add five words to it, or wrote half a li
Thereof; the whole, and every whit is mi

Also for *This*, thine eye is now upon,
The matter in this manner came from no
But the same heart, and head, fingers and
As did the other. Witness all good men.
For none in all the world without a
Can say that this is mine, excepting I.

I write not this of any ostentation,
Nor 'cause I seek of men their commenda
I do it to keep them from such surmize,
As tempt them will my name to scandalize
Witness my name, if Anagram'd to thee,
The Letters make, *Nu konjy in a B.*

MARGINATED

Seventeenth-Century Printed Books and the Traces of Their Readers

February–April 2010

Bruce Peel Special Collections Library

University of Alberta

SYLVIA BROWN & JOHN CONSIDINE *with the assistance of Amie Shirkie*

Bruce Peel Special Collections Library
B7 Rutherford South
Edmonton, Alberta, Canada
T6G 2J4

Editor: Linda Distad
Digital Reproduction: Jeff Papineau
Exhibition Installation: Carol Irwin
Book Design: Alan Brownoff

LIBRARY AND ARCHIVES CANADA
CATALOGUING IN PUBLICATION

Brown, Sylvia, 1966–
 Marginated : seventeenth-century printed books and the
traces of their readers / Sylvia Brown and John Considine ; with
the assistance of Amie Shirkie.

Includes bibliographical references.
Catalogue of an exhibition held at the Peel Special Collections
Library, Edmonton, Alta. from Feb. – April, 2010.
ISBN 978–1–55195–256–7

 1. Early printed books—17th century--Exhibitions.
2. Books—Owners' marks—History—17th century—Exhibitions.
3. Marginalia—History—17th century—Exhibitions. 4. Books
and reading—History—17th century—Exhibitions. 5. Bruce Peel
Special Collections Library—Exhibitions. I. Considine, John, 1966–
II. Bruce Peel Special Collections Library III. University of Alberta.
Library IV. Title.

Z1033.A84B75 2009 097 C2009–905583–X

Introduction

"one of those places, marginated by
his Maiestie"
— WILLIAM BARLOW, *An Answer to
a Catholike English-man* (London: printed
by Thomas Haueland for Mathew Law,
1609), 335.

Just over a decade ago, the Bruce Peel Special
Collections Library of the University of Alberta
presented an exhibition of sixteenth-century
books, and a few others, which showed the traces
of their owners and readers. The title of the exhib-
ition and of its catalogue (Considine 1998; cf.
Kallendorf 2001) was *Adversaria*, in the sense
"manuscript annotations in books," a word which
has been applied to annotations which preserve
major scholarly commentary. The exhibition was
not, however, simply a showcase for richly anno-
tated volumes. Its aim was to present more diverse
and less glamorous material, from unusual bind-
ings to annotations by children, and thus to give
a sense of the interest and diversity of the stories
told by some of the sixteenth-century books in a
good North American institutional collection.

This exhibition is, in some ways, a sequel to the
1998 *Adversaria*. Like *Adversaria*, it takes a century's
worth of books as its subject, and displays a wide
range of evidence for their reading and handling.
Its title, *Marginated*, is a seventeenth-century word

meaning "provided with marginal annotations,"
but though such annotations are prototypical
of the material gathered here, they are not the
most significant feature of every volume. Of the
exhibits catalogued here, the one which we think
may strike most readers as remarkable is the
one in which a lost manuscript of Philip Sidney's
Arcadia resurfaces (item 4 below), but it does so
as a binding fragment rather than as marginal
commentary, a reminder that there may be some-
thing to be learned from the study of any feature
of an early modern book.

The study of signs of ordinary readership and
ownership in early modern books has moved
briskly since 1998. For instance, David Pearson's
essential handbook for the study of provenance
(1994/1998) was already available in that year, but
his equally important treatment of English book-
bindings only appeared in 2005; similar volumes
which would give ready access to the stories
told by continental European ownership inscrip-
tions and bindings are much to be desired. Much
information about signs of reading has become
available online, some of it in library catalogues,
though some only elusively or ephemerally in
booksellers' printed or online listings. (We know,
for instance, that a copy of George Hickes's
Institutiones grammaticae anglo-saxonicae of 1689,
which includes an Icelandic dictionary, was given
to Humfrey Wanley by Arthur Charlett and has

Wanley's important manuscript additions to the dictionary — but we know it from catalogues of the booksellers Karen Thomson and Rulon-Miller, and not, or at least not yet, from the catalogue of a permanent collection.) Going beyond such scattered records, books such as H.J. Jackson's *Marginalia* (which focuses on the period after 1700) and Evelyn Tribble's *Margins and Marginality* (which focuses on printed notes in margins) have opened up new lines of inquiry. A few valuable contributions (e.g. Kallendorf 2005) have taken the story beyond texts in English. William Sherman's brilliant *Used Books: Marking Readers in Renaissance England*, published in 2007, is the first major monographic treatment of its particular subject, and draws on a wide variety of work by others, which we will not attempt to summarise here.

However, Sherman mentions only five exhibition catalogues "specifically devoted to the marks of readers from the European Renaissance" (185), *Adversaria* being one. The more such exhibitions are curated, the better, for any library with a few hundred early modern printed books on its shelves is likely to have dozens of individual volumes whose annotations or other marks of ownership are worth publishing. Often, the significance of such volumes becomes more evident when they can be compared with similar ones in other libraries: for instance, the ownership of item 11 below by Thomas Foley of Great Witley Court would mean much less by itself than it does side by side with his ownership of books on related subjects at Corpus Christi College, Cambridge, Dartmouth, Harvard, and the Huntington. How many other libraries have books of his?

☞

The books in this exhibition have been grouped roughly in threes. Different groupings would of course have been possible: for instance, we did not make groups with the headings "schoolroom annotations" or "the Bible" or "women's ownership inscriptions" or "bindings," although groups of three or four books in all four categories could readily have been assembled from the books we chose; indeed, an attractive and variegated exhibition of sixteenth- and seventeenth-century bookbindings could readily be put together from the holdings of the University of Alberta.

The first group of books exhibited here have marks relating to their acquisition: an author's presentation copy (1); a book with a price written in it, together with a comment on the price written by a later hand (2); and one with post-seventeenth-century book labels (3). The second and third of these open up a theme which is important throughout this exhibition: the life of seventeenth-century books after 1700. For a reader as late as the nineteenth century, a seventeenth-century book might be a working copy rather than a museum piece: hence the willingness of some readers for what would become the *Oxford English Dictionary* to cut up early modern books and glue the cuttings onto index slips when supplying the dictionary with quotations (Murray 1977, 139).

The second group all re-use parts of earlier books in their construction: strips cut from a literary manuscript strengthening a binding (4); sheets of a translation of the Bible marked up for a new edition (5); and old liturgical manuscripts used as the outermost layer of the binding of new printed books (6). Here, the theme is really the opposite to that suggested by item 3: we see books written or printed before the seventeenth century entering into the physical make-up of seventeenth-century books, an equivalent to the palimpsests of late antiquity and the Middle Ages.

The books in a third group all have the marks of referencing systems added by readers: a book

which has had its pages foliated to make its sections more readily accessible (7); a little atlas which has had projecting tabs added to a number of its maps, together with a record of their price (8); and a remarkable piece of evidence for an ephemeral referencing system, a book which has apparently had paper slips with notes written on them stuck to its margins (9).

The books in the next group have all been annotated in their margins, at different levels of sophistication. The first (10) has annotations which go little beyond repetitions of "not[a] ... not[a]"; the second (11) has annotations which summarize the text, meant for the continuing use of an active and careful reader; the third (12) has critical, questioning annotations which are really part of a practice of critical reading. Writing marginalia and thereby registering critical reading leads, through this sort of biblical criticism or through the criticism of ancient literary texts, to the discipline of modern literary criticism.

The trio of interleaved books which follows (13–15) were all used by students at different levels of education. Books could be interleaved by a binder, to order (cf. Jackson 2001, 33–36) or in the expectation that the interleaving would be welcome. They might also be issued interleaved with plain paper, as was done with Cambridge editions of Lycophron and Plutarch of 1595 (for both of which see McKitterick 1992, 120), and an Oxford edition of the *Characters* of Theophrastus of 1604. In these cases, interleaved copies went straight into institutional libraries.

The books which follow these are characterized by the printed imitation of manuscript marginalia. In one of these cases (16), the use of printed *maniculi* (pointing hands, otherwise known as manicules or fists) is perhaps a matter of taking a trick of layout over from the medieval manuscript tradition into the early modern printed one. In

the other two (17 and 18), both of which belong to the latter half of the seventeenth century, printed marginalia self-consciously imitate a tradition of manuscript annotation.

The next six books take up the story of items 10–12. Three show different ways in which the printed text could be supplemented in manuscript, whether by the explication of the text in marginal notes (19), its copying as a whole (20), or the replacement of defective pages (21). Three more offer information about the terminal dates of a given reading (22), the age of a given book in a particular year (23), or the identity of an anonymous author (24).

Thereafter, a series of five books show multiple ownership marks: one with a series of owners beginning with a woman owner of the 1640s (25); two inscribed by multiple owners from single families, these being the heirs of Sir Francis Drake in one case (26) and the members of a Quaker family in the other (27); a rare logic textbook which seems to have been read by a group of Presbyterian students in seventeenth-century Ulster (28); and a popular romance with a variety of readers at the University of Cambridge and beyond (29). After this series come two books with false attributions of ownership: a godly work supposed on the flimsiest grounds to have belonged to John Bunyan's wife, and an Anglican text with a forged signature of John Bunyan himself (30–31).

The next three books show readers of major sixteenth-century poetry at work, annotating copies of Spenser's *Shepherds Calendar* (32) and *Faerie Queene* (33) with notes on passages supposedly connected with Sidney, and annotating Sidney's *Arcadia* with extracts from more recent poetry (34). We then turn by contrast to four books (35–38) from one of the great strengths of the University of Alberta collections, the writings

of godly Englishmen such as John Bunyan and Richard Baxter. Both of these men were prolific and popular authors, with devoted followings, especially among Nonconformists in the second half of the seventeenth century. Their books are undoubtedly the most scribbled on in this exhibition. This may reflect the intensely textual culture of godly readers, who were encouraged to keep spiritual account books of their "experiences," a development of the humanistic and pedagogical keeping of commonplace books. The word "experiences" might indeed include what we would mean by the term — daily happenings interpreted as providential or monitory — but among the scripturally-focused, it more usually referred to the collections of passages from the Bible that had proved instrumental in a conversion experience. Such readers accordingly navigated not only scripture but other godly books as well, looking out for and seizing passages that could be imprinted directly on their hearts, if not in a notebook.

The next three books are copies of three early editions of Thomas Fuller's *Holy Warre*, the first free-standing English-language history of the Crusades, and show the different directions in which very similar books might travel: one (39) to the children of a godly Yorkshire gentry family in the seventeenth century and then to a bibliophile in the same county in the nineteenth; one (40) to a poor neighbourhood of London in the 1820s and then to the family of the poet Browning; and one (41) to an eighteenth-century Bedfordshire clergyman of modest means.

A trio of items with political annotations follows. The first (42) shows a cryptic poem whose author had been executed for his writings long before it was transcribed into the volume on display here; the second (43) shows the heavy annotations of a gatherer and transmitter of news in a printed newsbook of 1645; the third (44) shows

retrospective annotations to poems of the early 1640s made after the Restoration. These records of English affairs in the tumultuous mid-seventeenth century are followed by three books which extend from the 1640s towards the end of the century: a copy of the *Eikon Basilike* attributed to Charles I (45) marked by someone more interested in its fold-out engraving than its text; one of a late edition of the poet Milton's response to it, *Eikonoklastes*, with adverse comments on Milton (46); and one of Milton's history of England (47), with at least one learned annotation.

The next nine items bring us back to godly books, but the first three introduce readers who were at least occasionally uninterested in their message; they comprise texts by Featley (48) and Bunyan (49–50) annotated by children. The markings of the irreverent young might appear in all sorts of books, and those displayed in the exhibition *Adversaria* (Considine 1998, 41–43) were all in secular volumes. However, it is tempting to imagine that childish embellishments to an early Bunyan might be made because this was one of the few volumes which the annotator was allowed to read on a long Sunday afternoon in a godly household. Having said that, we should not typecast young readers as irreverent; they often seem to have been particularly interested to inscribe their godly books, and their secular ones too, with seriously intended ownership marks.

A manuscript copy of a poem associated with Richard Baxter's engraved portrait appears next (51), with its printed source (52): throughout the early modern period, the relation between the printed, written, and indeed oral versions of texts was a dynamic one (see Fox 2000), and this pair of exhibits is a reminder that what had appeared in print could reappear in a later manuscript. The four copies of books by Bunyan which follow them show multiple aspects of the social life of

his books: an economy of gift and lending, for instance, but also, in three cases, the presence of shorthand annotations. These appear in a number of seventeenth-century books, and do not seem to have been studied. They would be a demanding subject; learning the systems of shorthand used in the seventeenth century requires considerably more than simply studying the manuals available to seventeenth-century buyers, like Thomas Shelton's *Tachygraphy* or Samuel Botley's *Maximum in Minimo* (one of the simplifications of Jeremiah Rich's system).

The final trio of books displayed here are deliberately miscellaneous: a book of poems of 1633 with earlier academic manuscript material reinforcing its binding and verses quoted from Dryden on its endpaper (57); a French grammar with an early schoolroom annotation (58); and a last text by Bunyan, from the last year of the seventeenth century, with some entirely inappropriate astrological notes written on its rear endpaper and pastedown (59).

☞

We would like to express our gratitude to Amie Shirkie of the Department of English and Film Studies at the University of Alberta, who has done valuable preliminary work on the selection and description of godly texts from the later seventeenth century. We are likewise grateful to our colleagues at the Bruce Peel Library for their generous assistance, and for their patience. The English word *marginated* is now most common as part of the common name of a species of tortoise, *testudo marginata*, and our progress on this project must occasionally have seemed reptilian in its slowness (*glacial* is no longer a good metaphor for advance in a world in which the glaciers are in retreat). We are particularly grateful to Jeannine Green, with whom we first discussed this project, and to Robert Desmarais, who has been its good angel, overseeing it from the signing of contracts to its final stage, and giving us access on the most generous terms to the collection from which we have made our selections.

he Hon:ble Sr John Robinson

tys Liftent of the Tower

don, & the Noble friend of

His servant

The Author

Feltham

(1)

OWEN FELLTHAM

Resolves: The eight Impressio[n]

(London: printed for A[nne] Seile, 1661)
BJ 1520 f32 1661

For the Hon:ble S:r John Robinson
His Ma:tys Lieftent of the Tower
of London, & the Noble friend of

His seruant

The Author

— Felltham

Felltham's *Resolves* is a collection of essays on moral topics such as "The Misery of being old and ignorant," augmented in this late edition with other writings. This copy is inscribed on its endpaper "For the Hon:^ble S^r John Robinson | His Ma:^tys Lieftent^t of the Tower | of London, & the Noble friend of | His seruant | The Author | Felltham"; Sir John Robinson (1615–1680) was lieutenant of the Tower from 1660 to 1679, and had been Lord Mayor of London in 1662/3.

The "eight Impression" of the *Resolves* exists in two states. One, represented by only three copies, includes a liturgy used by the Countess of Thomond during the period when the use of the Book of Common Prayer was proscribed by the Commonwealth government (Pebworth 1986). In the other, the gathering on which the liturgy is printed is not included, and a reference to the liturgy at sig. A2v of the preface to the reader has been deleted by the resetting of type. Ted-Larry Pebworth, who identified the former state of the book, believed that it was so rare because it was reserved for preservation copies. However, only one of the copies with the liturgy has a presentation inscription, and the University of Alberta copy, which does have a presentation inscription, lacks the liturgy and has the revised setting of sig. A2v. Pebworth notes that awkward spacing on sig. A2v betrays the resetting of type there; so does another detail, which he does not note, namely the striking out in pen of a line of the errata at sig. n4r which refers to a misprint in the liturgy.

There are other manuscript corrections in this copy, all of them taken from the errata. These may be associated with its presentation to Robinson. They are absent from the Huntington Library copy reproduced in the database *Early English Books Online*, which was not a presentation copy; correcting the errors of a printed book by hand gave it a personal quality. The same was done, almost certainly for the same reason, to a number of copies of John Donne's *Biathanatos* (1648), a significant proportion of which carry presentation inscriptions (an uninscribed one now at the University of Alberta is described briefly in Considine 1998, 34–35). Similar corrections appear in other seventeenth-century printed books such as Walton's *Lives* (1670), the University of Alberta copy of which has a couple of ostentatious corrections at pages 32–33 of the life of George Herbert but no presentation inscription (cf. Butt 1927–30).

SOME

THOUGHTS

CONCERNING

Education.

Doctrina vires promovet insitas,
Rectiq; cultus pectora roborant :
Utcunq; defecere mores,
Dedecorant bene nata culpæ.

Hor. L. IV. Od. 4.

The Third Edition Enlarged.

LONDON,

Printed for *A.* and *J. Churchill*, at the
Black Swan in *Pater-noster-row*, 1695.

(2)

JOHN LOCKE
Some Thoughts Concerning Education,
3rd edition

(London: printed for A[wnsham] and
J[ohn] Churchill, 1695)
LB 475 L6 1695

On the title page is an erased inscription and the ownership inscription "Ex Libris | D: Wal: Laurie" and on the front pastedown, the late book label of "Sir Robert Laurie[.]" The latter must be one of the Laurie baronets of Maxwelton, a title created in 1685 and extinct in 1848, five of whose holders (including the first, whose daughter Annie Laurie was celebrated in song) were called Robert. The third Laurie baronet was Sir Walter, who died in 1731, and the title-page ownership inscription is most probably his. In that case, the price written on the title page, one pound and five shillings ("pret: 01–05–00"), must be what was paid for the book at a point before it passed by inheritance into the possession of younger generations of the Laurie family. At first glance, this price looks absurdly high for a small and common book. But it is in pounds Scots; the pound Scots was worth one twelfth of the pound sterling, so one pound and five shillings Scots was worth two shillings and one penny sterling. The pound Scots was used only as a unit of account after the Act of Union of 1707, so the book was probably bought between 1695 and that date. Facing the title page is the inscription "The common price of this book is | 4 shilli. sterling": the person who wrote it may have been wondering whether the book had been bought cheap in pounds Scots, or dear in pounds sterling.

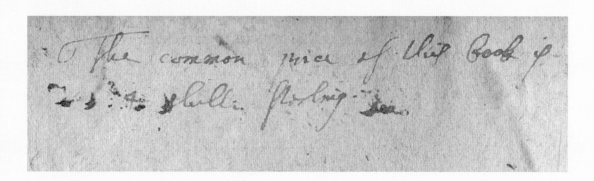

(3)

[MARY ASTELL]

Some Reflections Upon Marriage

(London: printed for John Nutt, 1700)

This discussion of the marriage contract as requiring a woman's absolute obedience to her husband, published in the last year of the seventeenth century, is of interest for its later ownership. The earlier of the book labels in it is that of the miscellaneous writer William Matthews of Bath (d. 1816; for his writings, see Smith 1867, 2:164–66). More remarkable is the rhyming label of Charles Clark (1806–80) of Great Totham Hall, Essex, beginning "As all, my friend, through wily knaves, full often suffer wrongs" and going on to ask that the book be not stolen or marked. Historians of book labels have noted that "there was a fashion for gently rebuking verses against retention and stealing of books on many Victorian examples" (Bookplate Society and Victoria & Albert Museum 1979, 17; see examples at Lee 1979, 150–53). This one amused several Victorian readers, and was published in a number of journals. Clark was a farmer, who printed books by way of a hobby (see Brignull 1990 and Clark ed. Hanchant 1932). He liked republishing rarities: Margaret Cavendish's poem "Nature's Cook" (from her *Poems* of 1668), printed as a broadsheet around 1835; an Essex witch-trial of 1645, printed with other short works in 1838; and *Flying and No Failure! or, Aerial Transit Accomplished More than a Century Ago*, reprinted from the *Narrative of the Life and Astonishing Adventures of John Daniel* (1751) in 1848. He was a Malthusian, and compiled and printed *Mirth and Mocking on Sinner-Stocking!* (1858 or later), an anthology of extracts from texts of the sixteenth century onwards to illustrate the unhappiness of marriage and parenthood; this helps to explain his interest in Astell's *Reflections*. Clark's library extended to more than 2500 volumes; other books with his rhyming label include copies of *Comforts of Matrimony* (1780), now in the New York Public Library, and Joseph Haslewood's edition of *Ancient Critical Essays upon English Poets and Poetry* (1811), now in the English Faculty Library at Oxford.

A PLEADER TO THE NEEDER WHEN A READER.

AS all, my friend, through wily knaves, full often suffer wrongs,
Forget not, pray, when it you've read, to whom this book belongs.
Than one Charles Clark, of Totham Hall, none to't a right hath better,
A *wight*, that same, more *read* than some in the lore of old *black*-letter.
And as C. C. in *Essex* dwells—a shire at which all laugh—
His books must, sure, less fit seem drest, if they're not bound in *calf!*
Care take, my friend, this book you ne'er with grease or dirt besmear it;
While none but awkward *puppies* will continue to "*dog's-ear*" it!
And o'er my books when book-*worms* "*grub*," I'd have them understand,
No marks the margins must de-*face* from any busy "*hand!*"
Marks, as re-marks, in books of Clark's, when e're some critic spy leaves,
It always him so *wasp*-ish makes, though they're but on the *fly*-leaves!
Yes, if so they're used, he'd not de-*fer* to *deal* a fate most meet—
He'd have the soiler of his *quires* do penance in a *sheet!*
The Ettrick *Hogg*—ne'er deemed a *bore*—his candid mind revealing,
Declares, to beg "a *copy*" now's a mere *pre-text* for stealing!
So, as some knave to grant the loan of this my book may wish me,
I thus my book-*plate* here display, lest some such "*fry*" should *dish* me!
—But hold,—though I again declare WITH-holding I'll not *brook,*
And "a *sea* of trouble" still shall take to bring book-worms "to *book!*"

1860

BINDING FRAGMENTS

(4)

WILLIAM ALEXANDER

Recreations with the Muses

(London: printed by Tho[mas] Harper, 1637)
PR 2369 S5 A5 1637

The binding of this volume has been strength-
ened with paper cut down from an old manuscript,
as was common. In this case, the manuscript was
a previously unrecorded scribal copy of Philip
Sidney's *Arcadia*. A context for the first lines of the
column of text displayed here can be taken from
the Oxford edition by Robertson (page 51, lines 25
onwards), where the spelling is modernized: so, the
University of Alberta fragment in old spelling and
Roman font is framed by context in new spelling
and italic font. The layout of text on the original
manuscript page must have been very like this:

> *the ancient records of*
> *Arca*dia say *it fell out: the lion's presence had no sooner*
> *driven* away the *heartless shepherds, and followed, as I told*
> *ye, th* e excellent P*hiloclea, but that there came out of the same*
> *wood*s amonsthrous *she-bear which, fearing to deal with the lion's*
> *prey,* came furiously *towards the princess Pamela who, whe-*
> *ther* yt wear she *had heard that such was the best refuge against*
> *that* beste, or that *fear (as it fell out most likely) brought forth the effects*
> *of wi* sdom, she no *sooner saw the bear coming towards her*
> *but* shee fell downe *flat on her face. Which when the prince*
> *Mu*sidorus saw *(whom, because such was his pleasure,*
> *I am* bold to call the *shepherd Dorus, with a true res-*
> *olved* magnanimitie,

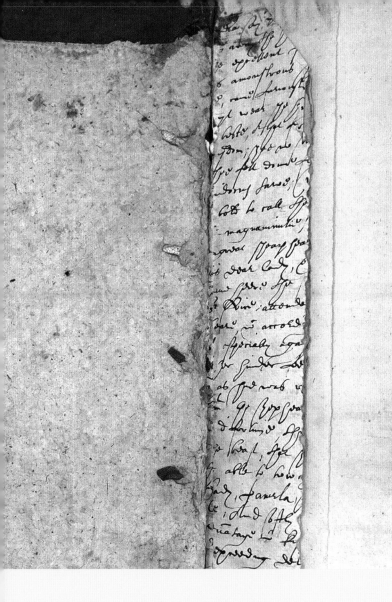

This text is from Book I of the so-called *Old Arcadia*, a complete five-book romance which was not printed until the twentieth century, and of which ten manuscripts were known before the fragments on display here were discovered. Sidney wrote the first two and a half books of a comprehensively revised version, the *New Arcadia*, and after his death, these were printed by themselves in 1590, and with the latter part of the *Old Arcadia* in 1593. The two versions did not join neatly together, and the *Arcadia* as sold from about 1618 onwards had the join concealed by a bridging passage written by William Alexander, the author of the volume

on display here. (The first issue of the 1613 edition, STC 22544, lacked Alexander's continuation; it was added to a second issue of this edition, STC 22544a3, which was available by 1618: see Sidney ed. Robertson 1973, lii.)

It cannot be a coincidence that this manuscript of the *Old Arcadia* has been found in the binding of a book by a contributor to the post-1621 version of the *New Arcadia*. But it need not be supposed that Alexander himself is responsible for the appearance of a manuscript fragment of *Arcadia* in the binding of this book, for Alexander's *Recreations with the Muses* has another connection

with the *Arcadia*: its printer, Thomas Harper. The 1590 *Arcadia* had been published by William Ponsonby. After Ponsonby's death in 1604, his brother-in-law Simon Waterson acquired many of his titles, and the 1613 *Arcadia*, including the issue with Alexander's contributions, was published for Waterson. In 1620, Waterson's son John took over the management of his business. Now, Thomas Harper was a regular associate of John Waterson's. Hence it was that Harper was one of the printers of the ninth edition of *Arcadia* (for John Waterson and others, 1638), of which a copy is displayed in this exhibition (item 34), Harper printing quires A-O and Robert Young the rest. Harper also printed some of Sidney's psalm translations in 1632, and then some of William Alexander's psalm translations (represented as being by King James) in 1636, with a second edition in 1637. This work doubtless came to him through the Watersons, and so, we believe, did the *Arcadia* manuscript. A manuscript of the *Old Arcadia* is known to have been available to the printers of the 1613 *Arcadia*, which as we have just seen was published for Simon Waterson (Sidney ed. Robertson 1973, lxiii). We believe that this manuscript remained in Simon and John Waterson's possession until 1633, when the eighth edition of the *Arcadia* was printed by Robert Young and published by Young, John Waterson (under his father's name), and T. Downes. By this time, it had become useless: the *New Arcadia* was very successful, and there was no reason to hold on to a manuscript of a shorter, older version of the same

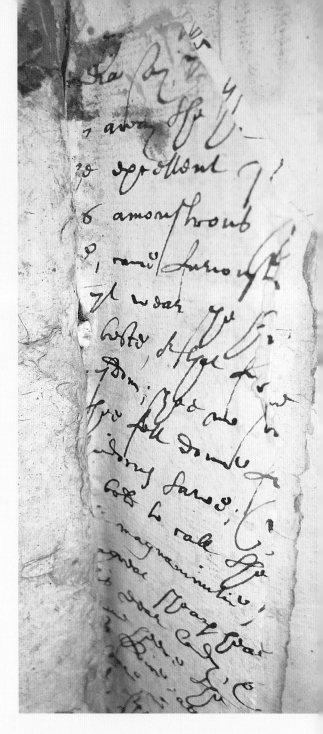

work. When John Waterson handed the manuscript over to Harper with the materials for the preparation of the 1638 *Arcadia*, the latter decided that there was no need to preserve it, and handed it over in his turn to a binder working for him.

(5)

EDWARD PHILLIPS

The New World of English Words, or,
A General Dictionary

(London: printed by E[van] Tyler for
Nath[aniel] Brooke, 1656)
PE 1620 P55

The striking feature of this copy of Edward Phillips's handsome but derivative dictionary is the use of leaves from a sixteenth-century Bible as pastedowns and endpapers; it can be identified as a copy of an edition of the so-called Great Bible, printed in London and Paris in April 1539 (STC 2068). The history of these leaves can be traced, because they carry very early annotations. These were made in a printing house, to typeset a new edition of this translation of the Bible. So, for instance, a quarter of the way down the right hand column of the first rear endpaper, in the text of Psalm 119, the paragraph indent before the words "O do well vnto" has been marked with a rectangle divided into six squares; this mark instructed a compositor to close up the paragraph break between this verse and the preceding one. Likewise, about halfway down the column, a line of type cut in half by the trimming of the endpaper originally read

lyte, and my councelers. ☞ * My soule

with ample space before the *maniculus* and the asterisk, both of which key the sentence which they precede, "My soule cleaveth to the dust …" to a marginal cross-reference to a parallel passage in Psalm 44. The divided rectangle instructs the compositor to close up the gap between the two sentences. Both gaps were duly closed in the next edition of the Great Bible, STC 2069; "O do well vnto" is now on the same line as the preceding sentence, and the setting of type after "my councelers" has been smartened up by moving the *maniculus* to the margin. Other printing-house marks on this leaf are less easy to explain. Above the heading "The .cxix. Psalme" are the numeral xxiiij and some further symbols and letters, of which the first may be interpreted as a monogrammic form of cc5. In STC 2069, as in STC 2068, Psalm 119 begins on the first column of folio xxiii recto, the signature being cc6, and in no edition of the Great Bible does it appear to begin on folio xxiiij. Do the printing-house marks here suggest

an abandoned plan for reformatting the Psalms in STC 2069?

Marked-up printer's copy was usually recycled as wrapping paper or lavatory paper after it had been used by compositors. Perhaps printing-house employees were reluctant to treat sheets of the Bible like this, and they were put away in a safe place after they had been used until, well over a century later, they were at last regarded as the sort of waste paper which could, without indecency, be incorporated into a bookbinding.

They kepte me i on euery syde, they kept me in (I saye) on euery syde, but in the name of the Lord, I wyll destroye them. They came aboute me lyke bees, and are extyncte, euen as the fyre among the thornes, for in ý name of the Lorde I wyll destroye them.

☞ Thou hast thrust sore at me, that I myght fall, but the Lorde was my helpe.

✻ The Lorde is my strength, ⁊ my songe, ⁊ is become my saluacyon. The voyce of ioye and health is in the dwellinges of the ryghteous: the ryght hande of the Lorde bringeth mightie thinges to passe. The right hande of the Lorde hath the preemynece, the ryght hande of the Lord bryngeth myghtye thynges to passe. I will not dye, but lyue, and declare the workes of the Lord. The Lord hath chastened and correcte me, but he hath not geuen me ouer vnto death. Ope me the gates of ryghtuouslnes, that I maye goo into them, and geue thanckes vnto the Lorde. Thys is the gate of the Lorde, the righteous shall entre into it. I wyll thancke the, for thou hast herde me, and art become my saluacyō. ✻ The same stone which the buylders refused, is become the heade stone in the corner. Thys was the Lordes doynge, and it is maruelous in oure eyes.

Thys is the daye, whych the Lord hath made, we wyll reioyse and be glad in it.

Helpe ✻ (me) now O Lord, O Lord sende vs now prosperyte. ✻ Blessed be he ý commeth in the name of the Lorde, we haue wisshed you good lucke, ye that be of ý house of the Lorde. God is the Lorde, whych hath shewed vs lyght: bynde the sacrifyce w coardes, ye euen vnto the hornes of ý aulter.

Thou art my God, and I wyll thancke the: thou art my God, I wyll prayse the.

O geue thanckes vnto the Lorde, for he is gracyous, and hys mercy endureth for euer.

⸿ The .cxix. Psalme.

BEATI IMMACVLATI.

B✻ Lessed are those that be vndefyled in the waye: and walke in the lawe of the Lorde. Blessed are they that kepe his testimonyes, and seke hym with theyr whole herte. For they whych do no wyckednesse, walke i his wayes. Thou hast charged ý we shall diligently kepe thy commaundementes. O that my wayes were made

(6)

DOMINICUS ARUMAEUS

Commentarius juridico-historico-politicus de comitiis Romano-Germanici Imperii

(Jena: sumptibus Blasii Lobensteins, 1635)
JN 3250 C83 A79 1635

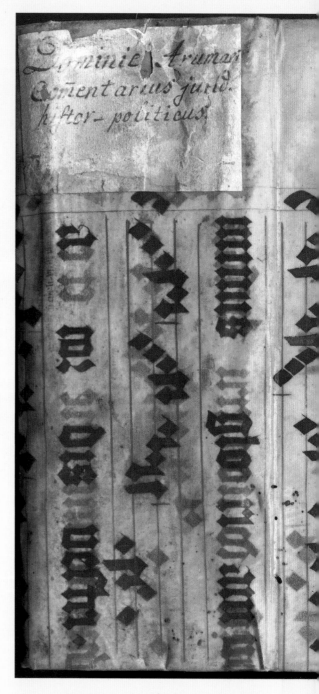

This treatise on public law by the Dutch jurist Dominicus Arumaeus (van Arum) argued that the Holy Roman Empire was a limited monarchy with aristocratic government. Its title page has the ownership inscriptions of Erasmus Pascha (1568–1643), professor of law at Ingolstadt, and of his son Johann Heinrich Pascha (d. 1701), who notes that he had the book *titulo hereditatis*, "by hereditary right." From 1667, the younger Pascha was director of the consistory at Salzburg, and a bookplate of 1701 records that he gave this book to the archiepiscopal library in that year, probably by bequest. The outermost layer of its binding is a re-used liturgical manuscript, the visible texts being for the second Sunday of Advent, for instance "[po]pulus syon ecce domi[nus ... ueniet ad] saluandas gentes" on the front cover, and "israel intende qui deduci[s uelut ouem]" on the rear. The binding was doubtless commissioned by Erasmus Pascha, for very similar bindings are to be seen on other books about law with his ownership inscription which have come to the University of Alberta from Salzburg, for instance *Sacri Romani Imperii Jus Publicum* (three parts in two volumes, both 1633, ownership inscriptions dated 1640 and 1643). The vellum of the liturgical manuscript in these bindings is sufficiently translucent to show the material which underlies it, a kind of pasteboard made up from whole sheets of scrap paper (Pearson 2005, 23; cf. item 57 below). A couple of sixteenth-century books in bindings incorporating similar manuscripts are identified at Considine 1998, 10–11.

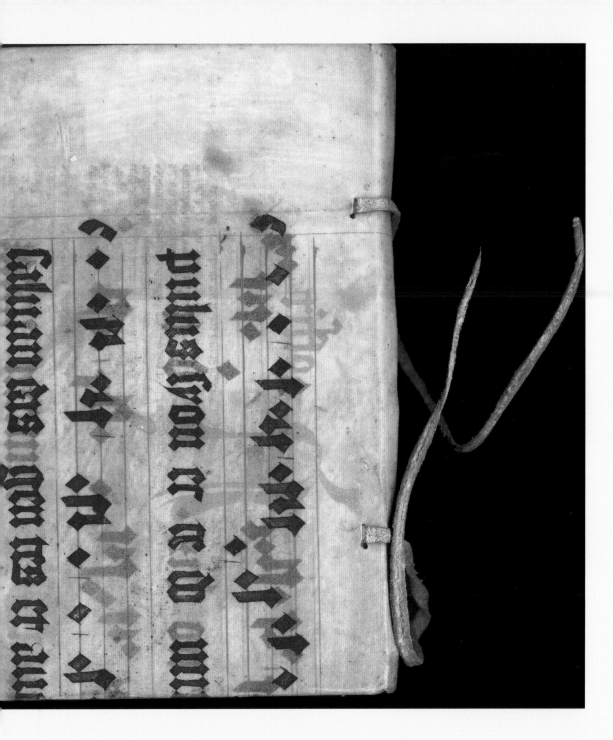

P.

w: 243:	Piccolomini	Ottavio	Seco
w: 252:	Pignatelli	Hettore	Sinovich
w: 256:	Pappenhain	Gofreddo	Slavata
w: 259:	Panfilio	Camillo	
w: 263:	Portia	Gio:Ferdinando	Truchi
w: 276:	Poderico	Luigi	Tilly
w: 281:	Paffano	Gio:Giachino	
w: 286:	Paffano	Bartolomeo	Valstain

R.

Vaymar

w: 290:	Ravanal	Ferdinando	Visconte

S.

Visconte

			Visconte
w: 295:	Spinola	Ambrosio	Visconte
w: 300:	Spinola	Filippo	Visconte
w: 311:	Sinzendorf	Giorgio Lodovico	Visconte
w: 313:	Slick	Henrico	Visconte
w: 315:	Sfondrato	Ercole	Villa
w: 332:	Sfondrato	Valeriano	Villa

Zvin

(7)

COUNT GALEAZZO GUALDO PRIORATO
*Vite et azzioni di personaggi
militari e politici*

(Vienna: appresso Michele Thurnmayer, 1674)
D 226.6 G92 1674

This collection of biographical sketches of generals and statesmen appears to have been issued in separately registered fascicles, with unnumbered pages, which could then be bound together with the publisher's general title page and other prelims. It therefore exists in various states of different lengths, with different articles included or omitted. In this copy, the pages have been foliated in manuscript from 1 to 436, the appropriate numbers being then added to the printed index of names which occupies the second leaf of the prelims. It lacks one entry for which the index calls, that for Tiberio Carafa, and adds one entry to the index, for Nicolo di Zrin. Other copies vary from this and from each other. The copy formerly owned by the entomologist and print-collector Frederick William Hope, and now in the Ashmolean Library at Oxford, has the pages numbered in manuscript from 1 to 733, and includes articles on Massimiliano Valentino de Martinitz and Fedrico Spinola for which the printed index does not call; the copy formerly owned by the historian Leopold von Ranke, now at Syracuse University, lacks the article on Tiberio Carafa but includes extra articles on Carlo Emanuel, Duke of Savoy, and Tomaso Francesco of Savoy; the copy formerly owned by the historian Lord Acton, now at Cambridge University, must lack several articles, for it runs to 618 pages and 53 portraits.

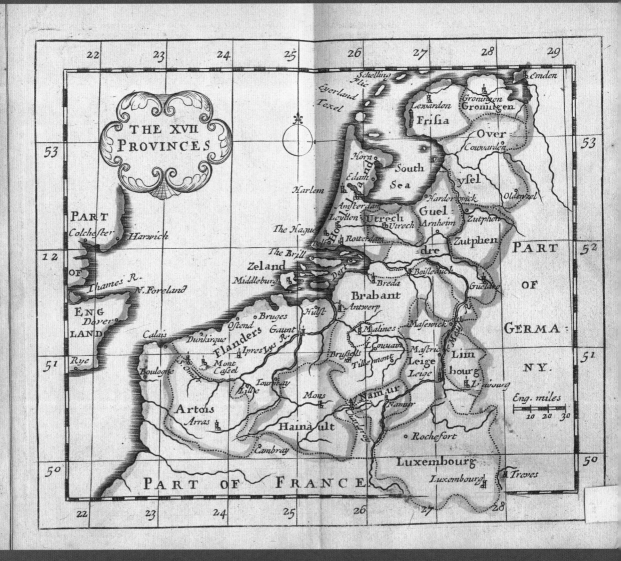

(8)

JOHN SELLER

A New Systeme of Geography

([London: for the compiler], 1685)
G 120 s46 1685

An inscription on the front pastedown of this geographical compendium reads

30 Maps &c tab: at 2d each –	5 – 0
Binding ————————	1 – 9
Description —————	1 – 0
	7 – 9

The first line refers to the improvement of the book with little labelled tabs so that a user could go directly to any of its maps (cf. item 13 below); most of these tabs have now been broken off, perhaps due in part to the schoolroom use attested by the inscription in a childish hand, upside down on a rear endpaper, "A Monsieur |

Monsieur de Boucher[.]" The five shillings this cost may have been more than the base price of the book, and was accompanied by quite a fancy binding in mottled calf with gilt tooling on the spine. The "description" which cost a shilling was presumably the colouring of the outlines of the maps. A reader has annotated a number of the lists of place names with Latin equivalents; these sometimes refer to the ancient world, as does the note "Incolae veteres Eburones" identifying Caesar's opponents the Eburones as the ancient inhabitants of the Duchy of Limburg, but sometimes to more modern Latin names, as does the note that Saint-Omer is "S. Audomeri" (the correct form is *Audomari*).

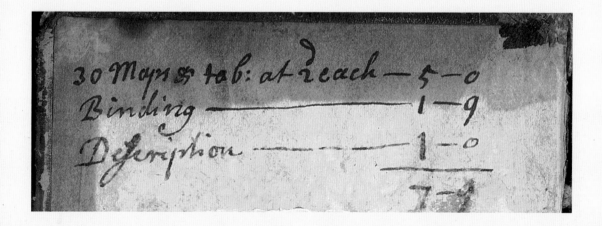

(9)

LOUIS THOMASSIN
La méthode d'étudier et d'enseigner
chrétiennement et solidement
la philosophie

(Paris: François Muguet, 1685)
PA 3019 T46 1685

The margins of this work by the philosopher
and theologian Louis Thomassin show where
numerous small slips of coarse blue-grey paper
have been pasted to them in an irregular distri-
bution and then torn off again. The likeliest
explanation for this is that the slips were written
on by a reader of the book and then pasted in
opposite the passages to which they referred,
before being removed; they would have made the
book harder to handle, quite apart from being very
possibly considered unsightly by a later owner. The
reader who made these slips was anticipating the
kind of annotation and referencing which has now
been made convenient by the invention of Post-It
notes.

miere, & autres chofes femblables, dont on s'eſt en-
fin détrompé, en ſe tenant ſimplement à ce que la
nature en enſeigne, qui eſt ce que nous en avons dit.
Nous ne ſçavons ny de Dieu, ny de l'ame quelle eſt
ſa figure, ſa couleur, ſa ſituation; mais nous ſçavons
que c'eſt une ſageſſe, une intelligence, une nature
dominante, qui meut & qui gouverne les corps; te-
nons nous-en à cela, & laiſſons tous les phantômes
corporels qui viennent enſuite offuſquer ces connoiſ-
ſances claires & évidentes. *Ubi igitur aut qualis eſt
iſta mens? ubi tua, aut qualis? Poteſne dicere? An ſi
omnia ad intelligendum non habeo, quæ habere vellem,
ne iis quidem quæ habeo, mihi per te uti licebit? Non
valet tantum animus, ut ſeſe ipſe videat: at ut oculus,
ſic animus ſeſe non videns alia cernit. Non videt autem
quod minimum eſt formam ſuam fortaſſe, quanquam id
quoque. Sed relinquamus: vim certè, ſagacitatem, me-
moriam, motum, celeritatem videt. Hæc magna, hæc
divina, hæc ſempiterna ſunt. Et un peu plus bas: Sic
mentem hominis, quamvis eam non videas, ut Deum
non vides: tamen ut Deum agnoſcis ex operibus ejus,
ſic ex memoria rerum, & inventione & celeritate mo-
tûs, omnique pulcritudine virtutis vim divinam mentis
agnoſcito.*

III. Le mépris que font ſouvent de cette vie les
plus ſages & les plus vertueux, la joye avec laquelle
ils en ſortent lorſque Dieu les appelle, ou leur donne
congé, enfin l'aſſurance qu'ils ont de paſſer d'une
profonde nuit à une lumiere & à une joüiſſance bien-
heureuſe de la Verité: ſont des preuves conſtantes,
que noſtre ame eſt étrangere dans cette vie mortelle,
& que ſa vraye patrie & ſon ſejour bienheureux eſt la
demeure des immortels Auſſi la vie de ces Philoſophes
n'eſt qu'une meditation & une preparation à la mort.
*Cato ſic abiit è vita, ut cauſam moriendi ſe nactum eſſe
gauderet. Vetat enim dominans ille in nobis Deus, in-
juſſu hinc nos ſuo demigrare. Cùm verò cauſam juſtam*

*Deus ipſe dederit, ut tunc Socrati, nunc Catoni, ſæpè
multis: ne ille medius fidius vir ſapiens lætus ex his
tenebris in lucem illam exceſſerit. Nec tamen illa vin-
cula carceris ruperit, leges enim vetant: ſed tanquam à
magiſtratu, aut poteſtate aliqua legitima, ſic à Deo evo-
catus atque emiſſus exierit. Tota enim Philoſophorum vi-
ta, ut ait idem, commentatio mortis eſt.* Pluſieurs ſe
ſont donné la mort à eux-meſmes par un deſir preci-
pité d'une vie immortelle, dont ils ne pouvoient dou-
ter, & Ciceron raconte que le nombre en eſtoit ſi
grand des ſeuls auditeurs du Philoſophe Hegeſias,
après l'avoir oüi diſcourir de l'immortalité de l'ame,
que le Roy Ptolemée luy fit défenſe de continuer ces
ſortes de diſcours. *A malis igitur mors abducit, non
à bonis, verum ſi quærimus. Hoc quidem à Cyrenaïco
Hegeſia ſic copioſè diſputatur, ut is à Rege Ptolemæo
prohibitus eſſe dicatur illa in Scholis dicere, quòd his
auditis mortem ſibi ipſi conſciſcerent.*

IV. Dans un autre ouvrage Ciceron prouve l'exi-
ſtence d'une ſuprême Divinité, qui regiſſe ſagement
ce monde: par la neceſſité de trouver une ſource pro-
fonde & inépuiſable de ſageſſe de prevoyance, de
vertu & de juſtice, dont noſtre ame emprunte ce
qu'elle en a, comme elle emprunte tout ce qu'elle
poſſede dans ſon corps des Elemens dont ce monde
corporel eſt compoſé. *Aliud à terra ſumpſimus, aliud* L 2. De nat.
Deorum.
*ab humore, aliud ab igne, aliud ab aëre eo quem ſpiri-
tu ducimus. Illud autem quod vincit hæc omnia, ratio-
nem dico, & ſi placet pluribus verbis, mentem, conſi-
lium, cogitationem, prudentiam, ubi invenimus? unde
ſuſtulimus? An cætera mundus habebit omnia, hoc unum
quod plurimi eſt, non habebit? Et ſi ratione & ſapien-
tia nihil eſt melius, neceſſe eſt hæc ineſſe in eo quod op-
timum eſſe concedimus.*

V. En un autre endroit Ciceron a repreſenté les
exemples de ceux qui ont quelquefois apperçû les
choſes divines, les abſentes, les éloignées, les futu-

ὸ ωρειτε εωλά- 13	Adam enim prior forma-	Genes. 1. 27.
Eûs.	tus est; deinde Eva.	
ου οὐκ ἠπατήθη: 14	Et Adā non fuit deceptꝰ:	Genes. 3. 6.
ἀ απατηθεῖσα, ἐν	sed mulier seducta, obnoxia	
ζήσεσε.	facta est transgressioni.	
ιται δὲ Δ/ὰ τῆς 15	Salva tamen [per] ge-	
ς, ἐὰν μείνωσιν ἐν	nerationem liberorum, si	
ἀγάπῃ καὶ ἁγια-	manserint in fide ac dilecti-	
σμῷ Θεγοσύνης.	one & sanctificatione cum	
	castitate.	

CAPUT III.

[Epi]scopos, 8 & Diaconos Christianos depingit,
[cu]m vxoribus, 12 liberis & familia. 15 Et Ec-
[cle]sīam Dei nominat.

ὸ λόγος, εἴ τις ἐπι- 1	INdubitatus sermo, Si quis	Tit. 1. 6.
τῆς ὀρέγεται, κα-	episcopi munus appetit,	
ἔργυ ἐπιθυμεῖ.	honestum opus desiderat.	
ουῦ, τὸν ἐπίσκοπον 2	Oportet igitur Episcopum	
ον εἶναι, μιᾶς γυ-	irreprehensibilē esse, unius	
δρα, νηφαλέον, σώ-	vxoris maritum, vigilantem,	
όσμιον, φιλόξενόν,	sobrium, modestum, hospi-	
οῦ,	talem, aptum ad docendum,	
σάργυρον, μὴ πλή- 3	Non vinolentum, non	
ἡ αἰ[σ]χροκερδῆ: ἀλ-	percussorem: non turpiter	
ῶ, ἄμαχον, ἀφι-	lucri cupidum: sed æquum,	
ς,	alienum à pugnis, alienum	
	ab avaritia,	
ιῦ οἴκυ καλῶς προΐ- 4	Qui suæ domui benè	
ν τέκνα ἔχοντα ἐν	præsit, qui liberos habeat in	
ν μετὰ πάσης σεμνό-	subjectione cum omni reve-	
	rentia:	

(10)

His Maiesties Speach in This Last Session of Parliament Together With a Discourse of the Manner of the Discovery of this Late Intended Treason

(London: imprinted by Robert Barker, Printer to the Kings Most Excellent Maiestie, 1605)

DA 392 A2 1605

This short official collection of materials relating to the Gunpowder Plot was annotated on its very wide margins — they have since been cropped, but still give a sense of their former extent — by an early reader who generally confined himself (or herself) to underlining and writing the abbreviation *not* (Latin *nota*, "note") beside points of interest, of which he or she found many. This, when it is done as unselectively as it is here, is not a sophisticated reading practice. The annotator occasionally added a few words, which tend also to suggest unsophisticated reading; here, the note "earle of Salisbury" at sig. G1r is probably a reminder that the "he" of the printed text does refer back to Salisbury, who was explicitly identified on the previous page. An annotator with a lively critical intelligence might have been struck by the grotesque comparison made in the marked phrase, "hauing with the blessed Virgine *Mary* layd up in his heart the Kings so strange iudgement[.]"

rection, Rebellion, or whatsoeuer other priuate and desperate Attempt could bee committed or attempted in time of Parliament, and the Authors therof vnseene, except only if it were by a blowing vp of powder, which might bee performed by one base knaue in a darke corner; whereupon he was mooued to interpret and construe the latter Sentence in the letter (alledged by the Earle of *Salisbury*) against all ordinary sense and construction in Grammar, as if by these words, *For the danger is past as soone as you haue burned the Letter*, should be closely vnderstood the suddaintie and quicknesse of the danger, which should bee as quickly performed and at an end, as that paper should bee of bleasing vp in the fire; turning that word of *as soone*, to the sense of, *as quickly*. And therfore wished, that before his going to the Parliament, the vnder roumes of the Parliament house might bee well and narrowly searched. But the Earle of *Salisbury* woondering at this his Maiesties Commentary, which he knew to be so farre contrary to his ordinary and naturall disposition, who did rather euer sinne vpon the other

His Maiesties opinion for searching of the vnder roomes of the Parliament house.

ther side, in not apprehending, nor trusting due Aduertisements of Practises and Perils when he was truely enformed of them, wherby he had many times drawen himselfe into many desperate dangers: and interpreting rightly this extraordinarie Caution at this time to proceed from the vigilant care hee had of the whole State, more then of his owne Person, which could not but haue all perished together, if this designement had succeeded: Hee thought good to dissemble still vnto the King, that there had beene any iust cause of such apprehension: And ending the purpose with some merry iest vpon this Subiect, as his custome is, tooke his leaue for that time. But though he seemed so to neglect it to his Maiestie; yet his customable and watchfull care of the King and the State still boyling within him, And hauing with the blessed Virgine *Mary* layd vp in his heart the Kings so strange iudgement and construction of it; Hee could not be at rest till hee acquainted the foresaid Lords what had passed betweene the King & him in priuat. Whereupon they were also earnest to renew againe

G the

preſt and dilated to us, but in reſpect of our diſorders here at home we do inforce thoſe dangers and by which they are occaſioned; For I believe I ſhall make clear unto you, that both at firſt the cauſe of theſe dangers were diſorders, and our diſorders now are yet our greateſt dangers, and not ſo much the potency of our enemies, as the weakneſs of our ſelves do threaten us, and that ſaying of the Father may be aſſumed by us, *Non tam potentia ſua quam negligentia noſtra.* Our want of true devotion to heaven, our inſincerity and doubling in Religion, our want of Councels, our precipitate actions, the ſufficiency or unfaithfulneſs of our Generals abroad, the corruptions of our Miniſters at home, the impoveriſhing of the Soveraign, the oppreſſion and depreſſion, the exhauſting of our treaſures, waſte of our proviſions, Conſumption of our Ships, deſtruction of Men, This makes the advantage to our enemies, not the reputation of their Arms. And if in theſe there be not reformation, we need no Foes abroad, time it ſelf will ruine us.

To ſhew this more fully, as I believe you will all hold it neceſſary, that there ſeem not an aſpertion on the State, or imputation on the Government, as I have known ſuch mentions miſinterpreted, which far it is from me to propoſe, that have none but clear thoughts of the Excellency of his Majeſtie, nor can have other ends but the advancement of his glory: I ſhall deſire a little of your patience extraordinarily to open the particulars, which I ſhall do with what brevity I may, anſwerable to the importance of the cauſe and the neceſſity now upon us, yet with ſuch reſpect and obſervation to the time as I hope it ſhall not be troubleſome.

For the firſt then our inſincerity and dubling in Religon, the greateſt and moſt dangerous diſorder of all others, which hath never been unpuniſhed, and of which we have ſo many ſtrong examples of all States, and in all times to awe us, What teſtimony doth it want? will you have Authority of bookes? look on the collection of the Committee for Religion, there is too clear an evidence; will you have Records? ſee then the Commiſſion procured for compoſition with the Papiſts in the North: Mark the proceedings thereupon: you will finde them to little leſs amounting then a tolleration in effect, though upon ſome ſlight payments and the eaſineſs in them will likewiſe ſhew the favour thats intended, Will you have proofs of men, witneſs the hopes, witneſs the preſumptions, witneſs the reports of all the Papiſts generally, obſerve the diſpoſitions of Commanders, the truſt of Officers, the confidence of ſecrecies of imployments in this Kingdom, in *Ireland* and elſewhere, they all will ſhew it hath too great a certainty, and unto this add but the incontrolable evidence of that all-powerfull hand which we have felt ſo ſorely that gave it full aſſurance, for as the Heavens oppoſe themſelves to us for our impiety, ſo it is that we firſt oppoſe the Heavens.

For the ſecond, our want of Councels, that great diſorder in State,

with

with which there cannot be ſtability, if effects may ſhew their cauſes as they are, after a perfect demonſtration of them, our misfortunes, our diſaſters ſerve to prove it, and the conſequence they draw with them, If reaſon be allowed in this dark age, the judgment of dependencies and foreſight of contingencies in affairs confirm it. For if we view our ſelves at home, are we in ſtrength, are we in reputation equall to our Anceſtors? if we view our ſelves abroad, are our Friends as many as our Enemies? Nay more, do our friends retain their ſafety and poſſeſſions? do our Enemies enlarge themſelves, and gain for them and us? what Councel to the loſs of the *Pallatinate*, ſacrificed we our honour and our men ſent thither, ſtopping thoſe greater powers appointed for that ſervice, by which it might have been defenſible, what Councel gave direction to the late action? whoſe wounds are yet a bleeding, I mean the expedition to *Rhee*, of which there is yet ſo ſadd a memorie in all men, what deſign for us, or advantage to our State could that import? you know the wiſdom of our *Anceſtors*, the practice of their times, how they preſerved their ſafeties we all know and have as much cauſe to doubt as they had the greatneſs and ambition of that Kingdom, which the Old world could not ſatisfie againſt this greatneſs and ambition, we likewiſe know the proceedings of that Princeſs, that never to be forgotten Excellency of *Queen Elizabeth*, whoſe name without admiration falls not into mention with her Enemies, you know how ſhe advanced her ſelf, how ſhe advanced this Kingdom, how ſhe advanced this Nation in glorie and in ſtate, how ſhe depreſſed her Enemies, how ſhe upheld her Friends, how ſhe enjoyed a full ſecurity, and made them then our ſcorn, whom now are made our terror. Some of the principals ſhe built on, were theſe, and if I miſtake let reaſon and our Stateſmen contradict me.

Firſt to maintain (in what ſhe might) a unity in *France*, that that Kingdom being at peace within it ſelf might be a Bulwark to keep back the power of *Spain* by land.

Next to preſerve an amity and league between the States and us, that ſo we might come in aid of the low Countries, and by that means receive their Ships and help by ſea.

This treable-cord ſo working between *France* the States and us, might enable us as occaſion ſhould require to give aſſiſtance unto others, and by this means the experience of that time doth tell us, that we were not onely free from thoſe fears that now poſſeſs and trouble us, but then our Names were fearfull to our enemies. See now what correſpondency or actions had with this, ſquare it by theſe rules, that it induce a neceſſary conſequence of the diviſion of *France* between the Proteſtants and their *King*, of which there is too wofull and lamentable experience. It hath made an abſolute breach between that State and us, and ſo entertained us againſt *France*, *France* in preparation againſt us, that we have nothing to promiſe

Kk 3
out

(11)

T[HOMAS] F[ULLER]

The Sovereigns Prerogative and the Subjects Priviledge

(London: printed for Henry Marsh, 1658)

DA 396 A2 F96

This collection documents the controversies between Charles I and Parliament, topical material in 1658, as Fuller noted, ending his introduction with the hope that future councils of state would be happier than the last parliaments of Charles I, "the abrupt end whereof was the beginning of all our miseries" (sig. ¶¶2v). It has been systematically annotated with marginal summaries; the opening on display shows the first part of an analysis of a speech by Sir John Elliot of 3 June 1628, the opening of which on page 195 has been summarised "Shewes yᵉ dan- | gers of yᵉ King | dom from yᵉ | disorders at | home." Points 1 and 2 are taken directly from the printed text: "1 | The insincerity | & doubling in | Religion" and "2 | want of Councils[.]" The next, unnumbered, point adapts the text: "The meanes by | wᶜʰ Q Eliz p[re] | serued and advan | ced her self & | kingdom." These are designed to make information retrieval from the text as rapid as possible. This feature suggests, as does the book's simple sheepskin binding, that it was part of a working library (in which it was originally shelved in the old-fashioned way with the fore-edge outwards: hence the fore-edge title, "Prerog. & Priuil:"). The book has the armorial bookplate of Thomas Foley of Great Witley Court, Worcestershire, i.e. Thomas Foley MP (c.1641–1701), a member of a notable Presbyterian family of ironmasters and politicians. He was interested in matters of state, and particularly in the relation of king and people: he also owned copies of George Buchanan's *De Maria Scotorum Regina* (1571), now at the Huntington Library; of Richard Zouch's *Jurisdiction of the Admiralty of England* (1663), now at Harvard; of Sir Robert Filmer's *The free-holders grand inquest, touching our Sovereign Lord the King and his Parliament* (1680), now at Corpus Christi College, Cambridge; and of Milton's *Defence of the People of England* (1692), now at Dartmouth University. A note on the verso of the front flyleaf offers further suggestions as to the part this book played in Foley's collection:

> V[ide]. Collect[i]on of speeches in P[ar]l in yᵉ
> yeares 1640 1641. Bundle of Pamphl[ets]
> No. 2.
> Hackwell's Lib[er]ty of yᵉ Subject.
> Hutton & Croke's Argum[en]ts in yᵉ Case of
> Shipmoney. on Hambden's P[art].
> Argum[en]ts on yᵉ Hab[eas] Corp[us]
> ag[ains]t Sr Tho Darnell &c. } MSS N° 5.
> in yᵉ case of Loanes. }

(12)

Novum Testamentum graece et latine

trans. DESIDERIUS ERASMUS

> (Wittenberg: typis haeredum Seuberlichianorum,
> impensis haeredum Samuelis Selfisch, 1618)
> BS 65 1618

Published in the city where Martin Luther held a professorship of theology and posted his famous theses, this Greek and Latin New Testament was owned by "Joh[annes] Georgius Thech" in 1620 and later by "Adam Fleischmann," both of whom signed the title page. A German pastor named Georg Tech, or Georgius Thechius, with some printed funeral sermons to his credit, lived between 1601 and 1673; if this was the man who signed it in 1620, he might have acquired it as a university student training for the ministry. The book is heavily annotated in at least two hands, the more industrious and interesting annotator's hand having points in common with Thech's signature. The annotator shows a sustained interest in passages which have to do with baptism, marriage, and what might be called cases of conscience — the preoccupations one would expect of an active pastor. However one might speculate about the annotator's identity and interests, his annotations suggest a level of engagement with the text markedly different from that of the annotator of item 11. They suggest not only the intense study of scripture that one would expect from a Protestant committed to the principle *sola Scriptura*, but are also sometimes surprising in content, suggesting the latitude and even liberties that such readerly annotation of the Bible might allow itself. On the page displayed, a section of 1 Timothy, the annotator has noted beside a passage that states that a bishop must have only one wife that "hic non prohibe[n] | t[ur] nuptiæ secundæ | sed polygamia | simultanea": second marriages are not prohibited here, only polygamy. At the bottom of the page, the reader reflects on how 1 Timothy 2:14 ("And Adam was not deceived, but the woman was deceived," underlined and marked by an X in the margin) is to be understood. He suggests "Intelligend[us] est secundu[m] quidem: hoc modo: [n]o[n] est seduct[us] | scil[icet] prior Eva. vel [n]o[n] est decept[us] im[m]ediate a diabolo | sed p[er] mulierem": we are to understand something after "was not deceived," for instance that the man was not deceived inasmuch as Eve was deceived first, or he was not deceived directly by the Devil but by means of the woman. And, finally, beside the statement that the woman "will be saved through childbearing" (1 Timothy 2:15), the annotator rather idiosyncratically asserts that this passage means that women are not so much saved by childbearing as that the bearing of children does not impede their salvation.

		
Ἀδὰμ γὰρ πρῶτ[ος] ἐπλά-13 σθη· εἶτα Εὔα.	[a] Adam enim prior formatus est; deinde Eva.	Genes. 1. 27.
Καὶ Ἀδὰμ οὐκ ἠπατήθη: 14 ἡ δὲ γυνὴ ἀπατηθεῖσα, ἐν παραβάσει γέγονε.	[b] Et Adam non fuit deceptus: sed mulier seducta, obnoxia facta est transgressioni.	Genes. 3. 6.
Σωθήσεται δὲ διὰ τῆς 15 τεκνογονίας, ἐὰν μείνωσιν ἐν πίστει καὶ ἀγάπῃ καὶ ἁγιασμῷ μετὰ σωφροσύνης.	Salva tamen her per generationem liberorum, si manserint in fide ac dilectione & sanctificatione cum castitate.	

CAPUT III.

2 Episcopos, 8 & Diaconos Christianos depingit cum eorum uxoribus, 12 liberis & familia. 15 Et Ecclesiam domum Dei nominat.

		
Πιςὸς ὁ λόγος, εἴ τις ἐπι- 1 σκοπῆς ὀρέγεται, καλῦ ἔργυ ἐπιθυμεῖ.	Indubitatus sermo, Si quis episcopi munus appetit, honestum opus desiderat.	Tit. 1. 6.
Δεῖ οὖν τὸν ἐπίσκοπον 2 ἀνεπίληπτον εἶναι, μιᾶς γυναικὸς ἄνδρα, νηφάλεον, σώφρονα, κόσμιον, φιλόξενον, διδακτικόν,	Oportet igitur Episcopum irreprehensibile esse, unius uxoris maritum, vigilantem, subrium, modestum, hospitalem, aptum ad docendum,	
Μὴ πάροινον, μὴ πλή- 3 κτην, μὴ αἰσχροκερδῆ: ἀλλ᾽ ἐπιεικῆ, ἄμαχον, ἀφιλάργυρον,	Non vinolentum, non percussorem: non turpiter lucri cupidum: sed aequum, alienum a pugnis, alienum ab avaritia,	
Τῦ ἰδίυ οἴκυ καλῶς προϊ- 4 σάμενον, τέκνα ἔχοντα ἐν ὑποταγῇ μετὰ πάσης σεμνότητος:	Qui suae domui bene praesit, qui liberos habeat in subjectione cum omni reverentia:	
(Εἰ δέ τις τῦ ἰδίυ οἴκυ 5 προςῆναι οὐκ οἶδε, πῶς ἐκκλησίας Θεῦ ἐπιμελήσεται;)	[Quod si quis propriae domui praeesse non novit, quomodo Ecclesia Dei curabit?]	
Μὴ νεόφυτον: ἵνα μὴ τυ- 6 φωθεὶς εἰς κρῖμα ἐμπέσῃ τῦ διαβόλυ.	Non novitium: ne inflatus, in condemnationem incidat calumniatoris.	
Δεῖ δὲ αὐτὸν καὶ μαρτυ- 7 ρίαν καλὴν ἔχειν ἀπὸ τῶν ἔξωθεν: ἵνα μὴ εἰς ὀνειδισμὸν ἐμπέσῃ καὶ παγίδα τῦ διαβόλυ.	Oportet autem illum & bonum habere testimonium ab extraneis; ne in probrum incidat & laqueum calumniatoris.	

Ccc 3 Diaco.

INTERLEAVING

(13)

JOHANN JACOB SPEIDEL
Sylloge quaestionum juridicarum et politicarum

(*Tübingen: apud Philibertum Brunnium, 1629*)
KA.5 S742 1629

This copy of an alphabetically arranged index to questions of law, which, with many other early modern European law books, came to the University of Alberta from the library of the archbishops of Salzburg, was personalized in a number of ways before it entered that collection. It was inscribed at the foot of the title page "Ex libris Francisci Dücker ab Hasslau," i.e. the Austrian jurist Franz Dückher von Hasslau zu Winkel (1609–71; for another book from his library, see Considine 1998, 27–28). There are two mottoes in a contemporary hand on the endpaper facing the title page, both suggesting a law student with a wry sense of humour. The first, "Vt ante hac flagitijs ita nunc legibus laboramus," is from Tacitus (*Annales* 3.25; modern editions read "Utque antehac flagitiis ita tunc legibus laborabatur"), and means "as previously we were afflicted by vices, now by laws." The other, "Quemadmodum omnium rerum sic litterarum quoque intemperantia laboramus. Non uitae sed scholae discimus," is from Seneca (*Epistulae morales* 106.12), and was also quoted by Montaigne and Pascal: "as in everything else, we are also afflicted by intemperance in learning — we do not learn for life, but for the lecture-hall."

The book has been embellished with tabs showing where each alphabetical range of entries begins (cf. item 8 above and Considine 1998, 37), and it has been interleaved with blank paper. The annotations, in more than one hand, are scattered; the one on display, beginning "Clerici pro sepultura et administra | tione sacramentorum nihil exigere | possunt" ("the clergy cannot demand anything [i.e. any payment] for the burial of the dead and the administration of the sacraments"), touches on a long-debated question in canon law.

SYLLOGE
QUÆSTIONVM
JURIDICARUM ET
POLITICARVM (VLTRA QVATVOR-
DECIM MILLIA) MAXIMEQUE PRACTI-
cabilium, secundum Alphabeti & materiarum
seriem dispositarum.

QVÆ PER REMISSIONEM AD
PRÆCLARISSIMOS, AC NEOTERICOS IN-
primis *Authores deciduntur.*

OPUS, QUOD INDICIS UNIVERSALIS, LO-
corumque Communium vicem supplere potest.

Collectore

Johanne Jacobo Speidelio,
Sturgardiano.

Cominæus 5. Historiar.

OMNIBVS BONIS IN REBVS CONATVS IN LAVDE, EF-
fectus in casu est Sed ut hodie mores sunt, omnes sapiunt, omnes censent; Imò, qui
vult suaviter vivere in hac vita sine calumnia & invidia, is perindè facit, ac
qui vult in clarissimo sole sine umbra versari. Tam enim difficile est, in o-
mni genere vita accommodare se, & ita gerere,
ne quid erres.

TUBINGÆ,
Apud Philibertum Brunnium.
Anno M. DC. XXIX.

Dy. 218. com̄
Reſo.2. ſi 2.ſont dū pty & 2.dauē,& pols (*ut ſupra*) q̃
dlſy darbē al un dū pty & auē dáuē pty,neſt ſuffic̄, car
(party) eſt intend del lentier pty.

104.

Baker, T.42.El.Ba.roy.

Reſo.ſur evidence en *Ej.firme*, ſi plē m̄re en evid aſc̄
m̄tr en eſcript,record,ouSentence en lecclial Court ſur
q̃ queõn in ley ſurd̄, & def. offer p̃ demurr &c. plē ne p̃
refuſe p̃ joind’en demurr,ſil ne voil waiver ſon evid̄,Iſſ
ſi plē p̃duce teſtimo. ſi def. admit lour teſtm̄y dēe voier,
p̃ demurr &c. Le reaſon eſt q̃a m̄r en ley ne ſr̄a mis
en bouch de lay gents. Iſſ p̃ plē demurr *mutatis mu-*
*tandis,*mes ſur evid̄ p̃ ro.en informac̄ &c. counſel ro.ne
ſr̄a ar̄ct &c. mes Court p̃ direct̄ jury p̃ troũ ſp̄all m̄r
&c. cõe 34.H.8.Dr.53.

C.L.72.

104.

Boulſton, M.39.& 40.El.Banco.

Jud̄ ſi hõe ſiſt Cony-boroughs en ſon ter̄ q̃x encreaſe a
cy gr̄d nomb̄ q̃ ils deſtroy ter̄ ſon vicine, accõn ſur caſe
ne giſt,car p̃ tuer eux en ſon ter̄ dem̄ eānt *feræ nature,*
& laut̄ nad aſc̄ p̃perty en eux, ’go ne ſr̄a puny pur lour
dam̄.

Reſo. q̃ nul p̃ nõlm̄t erect Dove-cote , forſq̃ Sñor de
Mõr,& p̃ ēe puny en Leet,mes nul accõn giſt p̃ pticul̄
hõe p̃ linfiniteneſſe : Et de tiel opiñ q̃nt al nõll erecciõ
&c.fuit *Manwood* & Barons en lexchēq̃r Chamb.

ſup.73.ᵃ
72.6.

105.

Alden, H.43.El.Banco.

*Ej.firme,*def. plead q̃ les tēnts fuer’ &c. aunc̄ deſme
&c. & d̄d̄a judgm̄t ſi le Court voil conuſt̄, plē demurr.

Obj. ceo accõn eſt forſq̃ en n̄r̄e de treſp̄ & q̃ in aunc̄
tp̄s le terme ne fuit recoũ en ceo mes ſolem̄t vers c̄ēy en
reũ : Et neſt plea en treſp̄ de cloſe debruſe &c. Jud̄
46.E.3.1. Ai ter̄ en aunc̄ deſme ſr̄a ext̄d p̃ *elegit,*q̃a le
frankt rem̄ cõe fuit devē,& unc̄ linteſt del ter̄ eſt charḡ
p̃ c̄ execõn 7.H.7.10.

2.h.7.27.

Reſo. q̃ le plea fuit bon, 1. q̃a le cõn intendm̄t eſt,q̃
le

(right-hand page — handwritten notes)

in caſe. Moore. 453. q̃ attõn ſ caſe ne giſt for la
eſt q̃ iſt comon nuſain.

&c. Cr. 16. Jar. 490. 491. none can erect a dove Coat ſaue
by the lords licence except the lord of a mannor or the
owner of the Rectory & that it is not nuſans inquirable
or puniſhable in the leet. for if it were nuſans neither
L nor parſon could erect it. Bowell. v. Sanders et
ibi Boulſtons caſe negatur poſt’ ley.
m̄r v. Cr. 13. Jar. 382. Prat v. Moarn et Moore.
f. 238. Bonds ob y ꝶ it is inquirable in the leet &
that the lord may diſtrein or bring deꝶ for the amerciam̄t.

(14)

EDWARD TROTMAN

Epitome undecim librorum honoratissimi
et docti viri Edvardi Coke

(London: per assignat[ionem] J[ohannis] More Armigeri
[i.e. printed for Miles Flesher, John Haviland, and Robert
Younge, lessees of John More], 1640)
DA 385 G78 1640

This abridgement of the *Reports* of Sir Edward Coke was interleaved for the use of the law students who were its intended readership. There is heavy cross-referencing annotation in the margins, and notes on many, though not all, of the interleaves, usually in English, though occasionally in the Law French of the printed book.

The opening displayed here shows the numbering of cases in the outer margin (*Baker* and *Boulston* have both been numbered 104 by mistake, before *Alden* is numbered 105), together with cross-references to other numbered cases. The question in *Boulston* was whether a man who has rabbit warrens on his land is liable for the rabbits' destructive activities on the land of his neighbours. The judgement was that he is not, since rabbits count as wild animals which are not the property of a landowner, so that he cannot be punished for the damage they cause, and that the law concerning dovecotes is not relevant here. The interleaving then carries a manuscript summary of the legal status of dovecotes, with appropriate references to the literature on the subject; if they constitute an inquirable or punishable nuisance, they cannot even be erected by the lord of the manor or the rector, the implicit point being that the doves in one's dovecote are, unlike the rabbits in one's warren, one's property and therefore one's responsibility.

(15)

WILLIAM LILY

A Short Introduction of Grammar

(London: printed by M[iles] Flesher, R[obert] Young and
R[ichard] Hodgkinson, 1641) and Brevissima institutio,
seu ratio grammatices cognoscendae
(London: excudit Rogerus Nortonus, regius in latinis,
graecis, et hebraicis typographus, 1637)
PA 2084 L73 1641

Books like items 13 and 14, interleaved for the use of post-secondary students, might be preserved if the annotations on the interleaves were regarded as sufficiently mature and informative. Similarly annotated interleaved schoolbooks must very often have been discarded, and indeed the survival rate of early schoolbooks with or without interleavings has been quite low. This copy of a late edition of Lily's grammatical compendium for schoolboys (apparently published as a single book, and printed with continuous registration, despite the different dates and printers stated on the two title pages) was bound in calf with minimal blind tooling, not the cheapest of schoolbook bindings, and this may have helped its survival. The binder provided it generously with interleaves. It has the large, ornamental ownership inscriptions of at least one boy called John Blake, one dated 23 October 1702 and another dated 1701, but a third dated 1691. Some of the interleaves are filled with carefully written notes, though these appear rather inconsistently. For the most part, they are versions of the Latin of the *Brevissima institutio*, or appear to record points dictated by a tutor; for instance, the introduction to the different tenses of the verb at sig. B5r is supplemented by the note on the facing interleave "The present tence is | known by this sign doe | as ye preterperfect tense is | known by this sign did." A little more independence is shown by the annotation "Two to one is odds" facing page 69, which was prompted by the illustration of the use of the accusative case after the preposition *adversus* with the proverb "Ne Hercules quidem adversus duos" (Not even Hercules can stand up to two opponents).

Two to one is odds

con ellos, cinco horas enteras, y al fin h
Ilipa, que eſtaua no muy lexos de Seuil
Cayo Flaminio para la Tarragoneſa, y
Flaminio truxo de refreſco tres mil y
uallo, y con los que quedaran a Sexto
Oretanos (que es Alicante, llamada ant
el otro Proconſul M. Fuluio vencio lo
cerca de Toledo, y prendio al Rey Hy
aquellos Eſpañoles, como dize Liuio.
dos en ſus oficios, Flaminio combatio,
y rica, y predio en ella el noble Rey Co
cellia, y Holon, con muchos caſtillos,
Cuſibi, y fueſe a Toledo, y tomola a fue
cito de Vacceos, que viniera por ſocor
bado ſu oficio, entro con ouacion, y tr
libras (de peſo) de oro, y diez mil libra
da, y acendrada, ciento y treynta biga
deſte fue proueydo a la Eſpaña vlteric
ſoldados de refreſco, y trezientos de
Vaſcetanos, y pelearon con el cerca de
tandole ſeys mil Romanos, y los otros
al real, y de noche ſe huyeron, dexand
proueydo Lucio Plauto Hipſeo para
la vlterior, fue ſalteado Bebio por los
fue proueydo en ſu lugar Publio Iunio
gal, recogio Lucio Emilio la gente qu
Portugueſes, y venciolos, matando di
ſion tres mil y trezientos, có el real, y có
ron deſpues proueydos para la Tarrag
Cayo Cattinio, contra los quales ſe alç
Portugueſes. Mas Cattinio vencio los

Marginalia:

Tomã los Romanos a Hiliça.

Dec. 4. lib. 9. cap. 10.

No ſe ſabe què ciudades eran eſtas.
Toledo preſa.

Rota de Romanos.

Rota de Eſpañoles.

Rota de Eſpa

(16)

PEDRO ANTONIO BEUTER

*La coronica general de toda España,
y especialmente del reyno de Valencia*

(Valencia: en casa de Pedro Patricio Mey, 1604)
DP 64 B56 1604

This late edition of a sixteenth-century account of the history of Valencia guides the reader to significant passages by means of printed *maniculi* of two different sizes in the margin. As early as the fifteenth century, printers used *maniculi* in imitation of those with which earlier readers had pointed out significant passages, but in the early modern period they tended, like the one visible in item 5, to be "restrained in style and rigidly locked into their horizontal position … very limited in size and surprisingly uniform in appearance" (Sherman 2007, 37 and 39). These Spanish examples are comparatively exuberant.

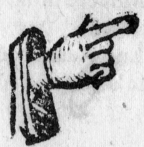

donde la España es rodeada del mar mayor dicho Oceano. Y tenia la Andaluzia, y Portugal partidas por el rio Guadiana, y rodeadas del mar Oceano por todas ellas. Estos varones que venian a España, algunas vezes venian como Consules, otras, como Proconsules, otras, como Pretores, proueydos segũ la qualidad del riẽpo, y neceſsidad de los negocios lo requerian. Partido pues M. Catõ, tuuo la España Tarragoneſa Sextio Digitio, y la vlterior Publio Cornelio. Y como todo lo trataſſen con rigor, y continuaſſen el pedir delos tributos, los Españoles no podiendo ſuffrirlo, alçaronſe, y mataron tantos Romanos, que fue vna gran perdida para Roma. Peleo Sexto Digitio, y fue ſiempre perdedor, tanto que no le quedo la tercera parte del exercito, y ſino ſocorrierã Publio Cornelio, que vencio algunas batallas cõtra los Iberos, los Romanos perdierã las Españas. Deſpues deſto, fue el miſmo Cornelio cõtra los Portugueſes que entrarã en el Andaluzia, y ſe lleuauan gran caualgada, y peleo con ellos, cinco horas enteras, y al fin huuo dellos vitoria, cerca de la ciudad Ilipa, que eſtaua no muy lexos de Seuilla. Deſpues deſtos, fueron proueydos Cayo Flaminio para la Tarragoneſa, y Marco Fuluio para la España vlterior. Flaminio truxo de refreſco tres mil y doziẽtos ſoldados, y trezientos de cauallo, y con los que quedaran a Sexto Digitio, tomo la ciudad Hilicia en los Oretanos (que es Alicante, llamada antiguamente Ilicen, como dizẽ algunos) el otro Proconſul M. Fuluio vencio los Vacceos, y Vectones, y Celtiberos cerca de Toledo, y prendio al Rey Hylermo, que venia por cabeça de todos aquellos Eſpañoles, como dize Liuio. Al año ſiguiente, que fueron confirmados en ſus oficios, Flaminio combatio, y tomo la ciudad Litabro muy fuerte y rica, y prẽdio en ella al noble Rey Corbulo. Fuluio tomo las ciudades Veſcellia, y Holon, con muchos caſtillos, y la ciudad Oliba en los Oretanos, y Cuſibi, y fueſe a Toledo, y tomola a fuerça de armas, auiendo rõpido vn exercito de Vacceos, que viniera por ſocorrerla. Por eſto, yendoſe a Roma, acabado ſu oficio, entro con ouacion, y truxo al theſoro ciento y veynte y ſeys libras (de peſo) de oro, y diez mil libras de plata ſin marcar, y de la marcada, y acendrada, ciento y treynta bigatos, que eran como marcos. En lugar deſte fue proueydo a la España vlterior Lucio Emilio Paulo, con tres mil ſoldados de refreſco, y trezientos de cauallo. Contra eſte ſe leuantaron los Vaſcetanos, y pelearon con el cerca de la ciudad Lycon, y le vencieron, matandole ſeys mil Romanos, y los otros con grandiſsimo eſpanto ſe retruxeron al real, y de noche ſe huyeron, dexando el carruaje. Y el año ſiguiente ſiendo proueydo Lucio Plauto Hipſeo para Tarragona, y Lucio Bebio Rico para la vlterior, fue ſalteado Bebio por los Genoueſes, y Murio en Marſella, y aſſi fue proueydo en ſu lugar Publio Iunio Bruto, y antes que llegaſſe a Portugal, recogio Lucio Emilio la gente que pudo de rebato, y peleo contra los Portugueſes, y venciolos, matando diez y ocho mil dellos, y tomando a priſion tres mil y trezientos, cõ el real, y con eſto ſe pacificaron las Españas. Fueron deſpues proueydos para la Tarragoneſa Lucio Manlio, y para la vlterior Cayo Cattinio, contra los quales ſe alçaron los Caſtellanos Celtiberos, y los Portugueſes. Mas Cattinio vencio los Portugueſes cerca de la ciudad Haſta, y mato cerca de ſeys mil dellos, y les tomo el real, y deſpues combatiendo la ciudad al ſubir en los muros que hizo, deſcuydadamente fue muerto, y fue preſa la ciudad. En la Tarragoneſa Lucio Manlio Accidino peleo con los Caſtellanos haſta la noche ſin vencer los vnos, ni los otros, ſino que en la noche los Eſpañoles dexaron el real, y ſe fueron. Deſpues ayuntandoſe mas gentes cerca de Calahorra, fueron vencidos los Eſpañoles, y muertos doze mil dellos.

Marginal notes (left):

Mueren muchos Romanos en España. Rota de Eſpañoles.

Tomã los Romanos a Hilicia.

Dec. 4. lib. 9. cap. 10.

No ſe ſabe que ciudades eran eſtas. Toledo preſa.

Rota de Romanos.

Rota de Eſpañoles.

Rota de Eſpañoles.

Batalla dudoſa.

Rota de Eſpañoles.

dellos, y preſos dos mil, y perdieron el real. Por eſto acabadõ ſu oficio entrõ en Roma con ouacion, que era medio triunfo, y truxo al theſoro cincuenta y dos coronas de oro, que las ciudades de España embiauan, y mas ciento y treynta y dos libras de oro, y diez y ſeys mil y trezientas de plata. Y dixo en el Senado, que Quinto Fabio theſorero, traya ochenta libras de oro, y cinco mil libras de plata. Sucedieron en la Tarragoneſa Cayo Calphurnio Piſo, y en la vlterior Lucio Quinto Criſpino. Y como los Carpetanos tuuieſſen gentes en campo, fueron los dos Pretores a la ciudad Beturia, y ayuntando alli ſus dos exercitos, fueron a los enemigos, que teniã el real entre Toledo y Dippo, y pelearon con los Eſpañoles, y fueron vencidos los Romanos y retraydos a ſu real, y en la noche ſe huyeron, dexando el real. A la mañana los Eſpañoles fueron con ſu batalla ordenada para pelear, mas como vieron el real deſamparado tomaronle, y fueron algunas compañias en el alcance delos Romanos, y mataron cinco mil dellos, y tomaronles grandes deſpojos, y muchas armas que dexauan por huyr. Mas luego deſpues rehaziendoſe con ſocorro de los de ſu vando, boluieron contra los enemigos, y paſſando Tajo a vado donde ſe podia bien paſſar, pelearon con los Celtiberos que no ſe auian pueſto en ordẽ, y vencieronles, y tomaron el real. Eran los Eſpañoles mas de treynta y cinco mil, y ſolo quedaron tres mil armados, que tomaron vn montezico donde ſe defendieron, y quatro mil armados ſe fueron, y mil otros ſe huyeron por los campos dexadas las armas, todos los otros murieron, como Liuio dize, donde largamente cuenta eſta jornada. Fuerõ tomadas ciento y treynta y dos vanderas. Por eſto triunpharon los dos bultos a Roma, y truxo Cayo Calphurnio de los Portugueſes, y Caſtellanos ſetenta y tres coronas de oro, y diez peſos de plata, y Lucio Quinto Criſpino truxo de las meſmos otro tanto oro y plata al theſoro. A eſtos ſucedieron Cayo Terencio Varro en la Tarragoneſa, y Quinto Sempronio Longo, en la vlterior de Portugal, Andaluzia: donde Cayo enfermo, y murio. Mas Cayo Terencio alçandoſe los Suetanos, tomo a fuerça darmas la fuerte villa llamada Corbion, y vendio por eſclauos a los Corbieſos. Sojuzgados eſtos Nauarros, peleo deſpues no muy lexos de Ebro con los Celtiberos que auian enfortalecido muchas villas, y vencioles, y tomo a fuerça darmas las fortalezas, por lo qual acabo ſu año entro en Roma con ouacion, y truxo al theſoro ſeſenta y ſiete coronas de oro, y mas ochenta y dos libras (de peſo) de oro, y mil y trezientas y veynte libras de plata, como lo eſcriue Liuio. Sucedieron a eſtos en la Tarragoneſa Quinto Fuluio Flacco, y en la vlterior Publio Manlio. A la venida deſtos ſe alço la villa Vrbicna (que dezimos Arbeca) combatiendola Flacco, vinieron a ſocorrerla muchos Celtiberos, y deſpues de muchas eſcaramuças y batallas, ſin poder quitar el cerco de canſados ſe fueron, y la villa fue tomada: por lo qual, el verano ſiguiente ſe ayuntaron treynta y cinco mil Celtiberos, quantos nunca antes ſe ayuntaran en Carpetania (que es el Reyno de Toledo) queriendo yr contra Fuluio: mas Fuluio les anticipo yendo con grã poder de los del vando Romano a buſcarles, y pueſto el real jũto a Eburia (que agora dezimos Talauera) tuuo alli la batalla, y fue vencedor, donde murieron veynte y tres mil Eſpañoles, y fueron preſos quatro mil y nueue cientos, con mas de quinientos cauallos, y ochenta y ſiete vanderas. De alli partio, y fueſe a la ciudad Cõtrebia, y tomola a partido, y viniẽdo deſpues los Celtiberos a ſocorrerla, detenidos por las aguas & llouiera muchas, deſbaratolos Fuluio, y mato doze mil dellos, y los otros huyerõ, ſegun largamente eſcriue Liuio. Por eſto no le auia de faltar la honra de la ouacion, que a los otros ſe diera quando

Marginal notes (right):

Rota de Romanos.

Rota de Eſpañoles. Dec. 4. lib. 0 cap. 10.

Triumpho de España.

Muerte de Sẽpronio. Los Nauarros ſe alçan.

Alçanſe los de Arbeca.

Ajuntamiento de Toledanos.

Rota de Eſpañoles. Lo meſmo dixe Oreſio. lib. 4. cap. 19. Tomaſe Contrebia. Rota de Eſpañoles.

H. 4 quando

You heart's *fire stills* the *moisture* of your *brain*,
Through your *Eyes Limbeck* which doth drop

al. An Ocean. * *amain*:
And whil'st your *lungs* the *fire* doth gently blow,

He meaneth her blinde cheeks. *Eye-water* drops into your * *Cheeks below.*
The *running* of your *Eyes* doth sure maintain,
That you within have got a *Curdled Brain.*
Within those Windows Fancy oft was fed,
In which that Spider spins a watry web;
Your *Eyes* are *pregnant* with those drops, and cry
Out for your help in their *Delivery* :
Their *circled motion* turns each beam-like thred
Into a skain of spirituall *white-brown-thred* ;
Which *Nature's Semstress* uses when she knits
Each object to her in fantastick fits.
Their *Still* may *leak* ; but ne're those *waters* can

His mothers belly Quite *overflow your little* * *Isle of Man.*
Scollars want Gold , therefore their Brains they sift,
To strain for friends the finest *New-year's-gift* :

Thats, a nasty word. And so want I ; therefore my wit I * *poop*
The *mellow Apples* of your Eyes to *scoop*
With this my *Pen,* which in your *brine* I sop,
Which *Dripping bast's* your *raw cheeks* while they drop.
If for your sins, then let *Susanna's* eye
Drop more such *Beads* for Heaven's *Rosary.*

On

On a Blackamore Maid courting me.

A Dialogue.

KEep * off, thy *Chimney* hue offends,	* *The Kettle calls the Pottage-pot burnt arse. Author.*
From which (like *smoke*) thy breath ascends.	
My *Breath* is *smoke*; hence is my smart,	*Blackmore.*
That *fire* within *burns* up mine *Heart.*	
The *Fire* of *Love* I cannot see,	A.
Ægyptian darkness hinders me.	
This *Darkness* will soon pass away,	B.
If thy *Sun* but afford one *Ray.*	
My *Sun* of *Beauty* is not seen,	A.
If thy *dark Body comes* between.	
My *Body's* dark , but if thy *Light*	B.
Shine clear, it cannot force a night,	
When I would view thy *Sloe*-like eyes,	A.
Mists from thy *Moorish* face do rise.	
Clear dayes of *Love* these *Mists* foretell ;	B.
For *Heat* of Love shall them *expell.*	
But thou art *Black* , and wilt disgrace	A.
The pure whiteness of my face.	
I'me *Black* , then let it be my lot,	B.
To serve for you a *Beauty spot.*	
Thou art both *Black* , and what is worse,	A.
Thou'rt *clouded* in thy *Countrey's* curse.	
The *best clothes* Nature to thee gave,	
Are but sad *Emblemes* of a *Grave.*	
I'me clad in *Black* ; *Black's* mine aray,	B.
Hence I go *mourning* every day.	

Flay

(17)

Naps upon Parnassus

(London: printed for N[athaniel] Brook, 1658)
PR 1211 N22 1658

The title page of this collection of witty verses
and other pieces "added for Demonstration of the
Authors prosaick Excellency's" promises the reader
a bonus: its contents come "with Marginal Notes
by a Friend to the Reader." The printed marginal
notes often imitate explanatory commentary and
are consistently facetious, making academic wit or
an imitation thereof available to an audience with
no access to the appearances of such wit in manu-
script. One respect in which these marginalia do
contribute something new to the printed language
is in the comment on "my wit I *poop*" which says
"That's a *nasty* word": *poop* had had senses like
"blow a trumpet" since Chaucer, but the sense
"fart," which must be in the mind of the author of
the marginalia, is not documented before 1689 in
the current version of *OED*.

(18)

JOHN DENNIS

Remarks on a Book Entituled Prince Arthur

*(London: printed for S[amuel] Heyrick and R[ichard]
Sare, 1696)*

PR 3318 B5 P93 D42 1696

Dennis' *Remarks* is a scathing literary critique of
the *Prince Arthur* of Richard Blackmore, a Virgilian
poem which ran to three editions in two years, but
has not been admired recently. This copy contains
no manuscript marginalia, but like item 17, it
makes the reproduction in print of what appear to
be private or personal marginalia a selling feature.
The displayed opening is from the twenty-three
pages of "Annotations" which Dennis appended to
the main body of his text. These purport to be his
second thoughts about his own work, hurried into
print as if from annotations to proofs, for instance,
"Here was something left out in the Copy through
the hurry of writing" (p. 227). As a further example
of the easy commerce between manuscript and
print, purchasers of this book were invited to make
corrections by hand. The usual list of printed errata
is given with this excuse and instruction: "The
Author's Absence from the Town has occasion'd
the following errors, which the Reader is desir'd to
mend with his Pen." Marginalia and annotations,
whether printed or added by hand, could be under-
stood as a way to perfect a text, hence the notion
that such correcting marks added value to a book
(cf. item 1).

ANNOTATION.

Secondly, that supposing Æneas was afraid.

<div align="right">

Page the 79.

</div>

HEre was something left out in the Copy through the Hurry of writing. All this, to the Bottom of the next Page, is spoken by those who endeavour to defend the Fear of *Æneas* (of which the Reader is not advis'd soon enough.) It is my Opinion, that a better Excuse may be made for the Fear of Prince *Arthur*, than for that of *Æneas*, supposing them both afraid. A Man who considers the Differences of their Religions must easily consent to that, but then it is my Opinion , that the *Trojan* was not afraid.

ANNOTATION.

A Man must affirm something, or else he says nothing.

<div align="right">

Page 158.

</div>

EVery Negative includes an Affirmative.

<div align="right">

AN.

</div>

(19)

WILLIAM ALEXANDER
Recreations with the Muses

(London: printed by Tho[mas] Harper, 1637)
PR 2369 S5 A5 1637

This is another copy of Alexander's collected poetic works (see also item 4). Alexander's long biblical poem *Dooms-Day, or, The Great Day of the Lords Iudgement*, a predecessor to Milton's *Paradise Lost*, has been annotated — especially the first book, called "The first Houre" — by a reader interested in simple summaries, the occasional marking of striking passages, and the decoding of some of Alexander's allusive references. The poet's expressed amazement at atheists, "How some dare scorne (as if a fabulous lye) / That they should rise whom death to dust doth binde" has been turned by the reader's annotation into an allusion to "Sadduces": the Sadducees denied the immortality of the soul. On the opening displayed, "That glorious angell bearer of the light" is identified as "Lucifer"; a stanza which describes the war in Heaven between rebellious and loyal angels is summarized as "The ffal of Angels"; and a classical analogue (Phlegra, where Zeus overthrew the Giants) is marked with a *maniculus*. Stanza 51, where rebel angels are spared the fate of being turned into dust or air, "resev'd for more opprobrious stripes," is summarized with the notation "Their punishme[nt]." Then, as now, the markers of books were sometimes dull readers.

43

Whil'ft rais'd in hafte, when foules from h
By inundations of impetuous finne,
The flouds of Gods deep indignation fwel
Till torments torrents furioufly come in,
Damnations mirrours, models of the hell,
To fhew what hence not ends, may here b
 Then let me fing fome of Gods judgen
 That who them heare, may tremble at

44

Lucifor — That glorious angell bearer of the light,
The mornings eye, the Meffenger of day
Of all the Bands above efteem'd moft brig
(As is amongft the reft the month of May
He whom thofe gifts fhould humbled hav
Did (fwolne with pride) from him who g
 And fought (a traitour) to ufurpe his fo
 Yea worfe (if worfe may be) did prove

45

Their ftarry tailes the pompous Peacock
As of all birds the bafeneffe thus to prove
So Lucifer who did hels legions leade,
Was with himfelfe prepofteroufly in love
But better Angels fcorning fuch a head,
No flattering hope to leave their Lord c
 " Thofe who grow proud, prefuming
 " They others doe contemne, them ot

46

The divell to all, an eafie way affords,
That ftrife which one devif'd, all did con
Their armour malice, blafphemy their fo
Darts fharp'd by envy, onely aym'd at g
They when they met, did need to ufe no
The thoughts of others, who foone unde
 By bodies groffe when they no hindr
 Pure fprites (at freedome) all things r

47

As where uncleanneffe is, the Ravens re
The fpotted band fwarm'd where he fp
Who fondly durft with God (foule foo
And his apoftafie applauded all,
Then to ufurpe heavens throne, did be
So hafting on the horrour of their fall,
 Whofe trayterous head made (like a v
 His flaming beauties prodigall of ray

48

Whil'st vainely puft up with preposterous aymes,
He even from God his treasure striv'd to steale,
The Angels good (those not deserving names)
With sacred ardour, boldly did appeale;
Their eyes shot lightning, and their breath smoak'd flames,
As ravish'd with Gods love, burnt up with zeale.
 All lifted up their flight, their voyce, their hands,
 Then sang Gods praise, rebuk'd rebellious bands.

49

This mutiny a monstrous tumult bred,
The place of peace all plenish'd thus with armes,
Bright *Mishael* forth a glorious squadron led,
Which forc'd the fiends to apprehend their harmes,
The lights of heaven look'd pale, clouds (thundring) shed,
Winds (roaring trumpets) bellow'd loud alarmes:
 Thinke what was fain'd to be at *Phlegra* bounds,
 Of this a shadow, ecchoes but of sounds.

The fall of Angels

50

O damned dog, who in a happy state,
Could not thy selfe, would not have others bide:
Of sinne, death, hell, thou open didst the gate,
Ambitions bellowes, fountaine of all pride,
Who force in heaven, in Paradice deceit,
On earth us'd both, a traitour alwaies try'd.
 O first the ground, still guilty of all evils,
 Since whom God Angels made, thou mad'st them divels.

51

When them he view'd, whose power nought can expresse,
To whose least nod the greatest things are thrall,
Although his word, his looke, his thought, or lesse,
Might them have made duft, ayre, or what more small,
Yet he (their pride though purpos'd to represse)
Grac'd by a blow, disdain'd to let them fall.
 But them reserv'd for more opprobrious stripes,
 As first of sinne, still of his judgement types.

Their punishions

52

Those scorned Rivals, God would judge, not fight,
And then themselves none else, more fit could finde,
Brands for his rage, (whil'st flaming at the height,)
To cleare their knowledge it with terrour shin'd,
Whose guilty weakenesse match'd with his pure might,
Did at an instant vanish like a winde.
 " Their conscience fir'd, who doe from God rebell,
 " Hell first is plac'd in them, then they in hell.

That

A DESCRIPTION
AND
EXPLANATION
Of 268. Places in
JERUSALEM

And in the Suburbs thereof, as it flourished
in the time of JESUS CHRIST.

Answerable to each of the 268. *Figures* that are in its
large, and most exact Description in the MAP;
Shewing the several places of the Acts and Sufferings of
Jesus Christ, and his *holy Apostles*.
As also of the *Kings*, *Prophets*, &c.

Very useful for the more clear and fuller opening
of very many places in the *Prophets* (as also in *Josephus*, and
other Histories) especially in the GOSPELS, and the
Acts of the Apostles.

Translated by *T.T.* Reviewed, and in many places rectified
according to the Holy SCRIPTURES, and some things further
cleared: With Additions of many Scripture proofs:

By H. *Jessey*.

Imprimatur *Joseph Caryl*.

London, Printed for *R I.* and *P. S.* and are to be sold by *Tho. Brewster* at the
Three Bibles in *Pauls* Church-yard, near the West-end. 1653.

(20)

[CHRISTIAAN VAN ADRICHEM,
trans. THOMAS TYMME, rev. HENRY JESSEY]

*A Description and Explanation of 268 Places
in Jerusalem and in the Suburbs Thereof,
as it Flourished in the Time of Jesus Christ*

*(London: printed for R[obert] I[bbitson] and
P[eter] S[tent], 1653)*
DS 109 A24 1653

The title page of this book of armchair travel shows what seems to be a note of intention or instruction: "a clerk to write." A clerk could be paid to copy out documents — a necessary service in the age before photocopiers. The Popish Plot informer William Bedloe asked, in 1678, to be reimbursed for "Mony laid out ... for a Clerk to write, and put in Order my Papers" (L'Estrange 1688, 124). Why might someone want a printed book copied out? This textual description of places of biblical and historical interest in Jerusalem was meant to accompany folding leaves of plates inserted at the end. The richly detailed plates are missing from the University of Alberta copy of *A Description*; they would have made an attractive and godly display on a wall. The map of Jerusalem was also printed and sold separately by John Overton in 1677. Could it be that an owner of the map or the plates alone was able to borrow this copy of the accompanying text and wanted it copied so as to own a complete text?

(21)

JOHN BUNYAN

The Acceptable Sacrifice:
Or the Excellency of a Broken Heart

(London: printed for Eliz. Smith, 1691)
PR 3329 A12

Here is a direct example of manuscript supplementing a deficiency in the printed text. An owner has carefully copied out missing pages, even attempting to imitate the typeface of the printed book. He or she has not, however, worried overmuch about reproducing other details of the printed text, such as italicization, punctuation, or paragraph breaks. Supplying missing leaves in pen facsimile was quite a common practice; the last leaf of the index of item 39 is another example.

ency of

that it is a hard
a wise Man. To
ter is a dreadful
here. with a Pe-
a Whip, a Mor-
he way. And if
e one *wise* in this
is will hardly do,
hat is so in Spiri-
eaten, and *striped*
se therein? Yea,
t into *God's Mor-*
en ; yea, *brayed*
l of the Law, be-
en unto heavenly
t Word in *Jere-*
t ; *that is, folly,*
, *saith the Lord.*

Why, *Therefore*
behold I will melt
hat is, with Fire)
the daughter of my

I will put them
d there will I try
 them

~~the, I will ~~ [struck through] ~~nace and there will I try them~~
them. and there I will make them know
me, saith, ye Lord. when David was under
spirituа Chastisement for his sins had
his heart under ye breaking hand of God,
then he said, God should make him
know Wisdom, Psal.51.6 Now he is in
the Morter; now he was in ye Furnace,
now he was bruised & melted; yea now
his Bones, his heart was breaking; & now
his folly was departing. Now says he thou
shalt make to know Wisdom. if I know any
thing of ye way of God with us Fools there
is nothing else will make us wise Men,
yea a Thousand Breakings will not
make us so Wise as we should be
We say Wisdom is not good, till 'tis
Bought; and he that buys it according
to the intention of that Proverb, usually
smarts for it. the Fool is wise in his
own Conceit. Wherefore there is a
double difficulty attends him before
he can be wise indeed: Not only his
folly, but his wisdom must be remo-
ved from him; and how shall that
be, but by a ripping up of his heart
 by

, ſo ſmooth and faſt,
rom Heaven ſent to be
ore happy is then ſhee.

FINIS.

le 20 de Feu: (66)

(22)

EDMUND WARCUPP, trans.

Italy, in its Original Glory, Ruine, and Revival

(London: printed by S. Griffin, for H. Twyford, Tho. Dring,
and I. Place, 1660)
DG 424 W25 1660

This handsome account of the history and geography of Italy has an eighteenth-century inscription in English in the middle of the title page, but a much more interesting one at the foot: "Je l'ay com[m]encè le 10 de Dec: (66)" matched with "Je l'ay Finy le 20 de Fev: (66)–7)" at the foot of the last page. The French-speaking owner who took eleven weeks to work through rather more than 300 pages of folio in English was reading steadily rather than fast: a pleasant occupation for the winter evenings. More common than this provision of both terminal dates for the reading of a book is the inscription "Perlegi" ("I have read it through") with or without a date at the foot of the last page; this is characteristic of books from the library of the diarist and virtuoso John Evelyn, but can be seen on many others, for instance the University of Alberta copy of William Drummond of Hawthornden's *History of Scotland* (1655), which is inscribed "Perlegi 1677" at the end. (This copy of Drummond, not on display here, has a few notes in the margins of early pages summarizing points which the annotator thought interesting, but these soon die out; it has the bookplate of John Bennett Lawes of Rothamstead, either the agriculturalist of that name (1814–1900) or his father (d. 1822), and like item 1 above, it has the book label of the twentieth-century collector Lawrence Strangman.)

VERSES composed on the Cities of *ITALY* translated out of the *ITALIAN*.

FOR *Pompe, and Pietie*, old Rome *is fam'd*,
Venice *is rich, the Sage, and Lordly nam'd*,
Naples *is noble, and of pleasant air*,
Florence *through all the world reputed fair:*
Milan *doth of her Grandeur justly boast.*
Bologna's *fatt:* Ferrara *civil most.*
Padoua *Learned;* subtile *Bergamo.*
And Genoua's *Pride, her stately buildings show:*
Worthy Verona, *bloudy* Perugia,
Brescia *well-armed; and glorious* Mantona.
Rimini *good.* Pistoia *barbarous.*
Babling Siena. Lucca *industrious.*
Forli *phantastick, kind,* Ravenna's *styld.*
Singalia *with nauseous air is fill'd.*
Pisa *is pendent: amorous,* Capua.
Pesaro *flowry; and (as all men say)*
Ancona *far from a good Port doth stray.*
Urbin *in her fidelity is strong.*
Ascoli *round, and* Recanate *long.*
Foligno's *candied streets most pleasant are.*
The Ladies of Fano, *so smooth and fair,*
That said they are *from Heaven sent to be*
But Modena *more happy is then shee.*

s

FINIS.

The Sexagenarian
Book entitled
F. Meres
Wits Commonwealth
1636

To his very good friend,
M^r B O D E N H A M,
N. L. wisheth increase
of happiness.

SIR,

W Hat you seriously begun long since,
and have always been very careful
for the full perfection of, at length
thus finished, although perhaps not so well to
your expectation, I present you with, as one
before all most worthy of the same; both in
respect of your earnest travel therein, and the
great desire you have continually had for the
general profit: My humble desire is, that you
would take into your kind protection this old
and new burthen of Wit: new in his form and
title, though otherwise old, and of great anti-
quity, as being a methodicall collection of the
most choice and select Admonitions and Sen-
tences, compendiously drawn from infinite va-
riety, Divine, Historical, Poetical, Politick,
Moral, and Humane. As for the envious and
over-curious, they shall the less trouble me,
with I know there is nothing in this World but

A 3 is

(23)

[NICHOLAS LING]

Politeuphia: Wits Commonwealth

*(London: printed by J Flesher, and are to be sold by
R. Royston, 1669)*

PR 2211 B8 P6 1669

This copy of a late edition of an Elizabethan prose anthology is inscribed "The Sexagenarian book entitled F Meres Wits Common-wealth 1636[.]" This note must have been written around 1696, and it is confused. Francis Meres' work was not *Politeuphuia: Wits Commonwealth* but the unauthorized sequel *Palladis Tamia: Wits Treasury*; there was no edition of either work in 1636; nor was either sexagenarian in the 1690s, *Politeuphia* having first appeared in 1597 and *Palladis Tamia* in the following year. A bibliographical kind of accounting found in the blank spaces of books is the sum to determine the age of a book, or intervals of time between one owner and another. A copy of a 1698 edition of John Bunyan's *Barren Fig-tree* owned by the University of Alberta (not displayed in this exhibition) contains such a sum, signed by "John":

$$1804$$
$$\underline{1698}$$
$$0106$$

A 1651 edition of Baxter's *Everlasting Rest* (item 38 in this exhibition) likewise has a reader's sum to determine how many years have passed between owners: 1827-1764 = 63 years (Second Part, 304).

(24)

[ROBERT MOLESWORTH]
***An Account of Denmark, as it was
in the Year 1692***

(London: np, 1694)
DL 109 M71 1694

Robert Molesworth had ingratiated himself to William of Orange before the Glorious Revolution, and was rewarded by being made envoy to Denmark in 1689. He did not shine in this posting; he disliked Danish absolutism, and is said to have poached in the King of Denmark's private preserves (King 1694, sig. a2r–v). Recalled in 1692, he revenged himself by writing this book. Although *An Account* was published anonymously, Molesworth's authorship was not a closely-kept secret, and at least one other early reader identified him as has been done here: an online listing current in March 2009 describes a copy of the first edition as "inscribed on title-page by Robt. Bristow, 1704, and in the same hand the author's name neatly entered below the title" (abebooks 2009). Bristow was writing earlier than the annotator of the University of Alberta copy, the inscription in which has the form "By Robᵗ. Lord Molesworth," and must therefore have been written after Molesworth was created Viscount Molesworth of Swords on 16 July 1716. The annotator of this copy also made a note on the first endpaper: "Mʳ Mennicks a Cane shop | at yᵉ bunch of Grapes | near yᵉ Green Dragon Tavern."

Other anonymously published books naturally got the same treatment. So, for example, the University of Alberta copy of a verse contribution to the seventeenth-century controversy between Jansenists and Jesuits in France, *Les enluminures du fameux almanach des PP. Iesuistes* (1654) is identified on the title page as "Par mʳ. de Sacy" (i.e., the theologian and Bible translator Louis-Isaac Lemaistre de Sacy), and the University of Alberta copy of the first edition of Milton's *Eikonoklastes* (1649) has the printed initials "I. M." on the title page expanded in manuscript to name John Milton.

AN
ACCOUNT
OF
Denmark,

AS

It was in the Year 1692.

*Pauci prudentiâ, honesta ab deteri-
oribus, utilia ab noxiis discer-
nunt; plures aliorum eventis do-
centur.* Tacit. lib. 4° Ann.

Vincit amor patriæ----Virg.

LONDON:
Printed in the Year 1694.

SEQUENCES OF OWNERSHIP

(25)

LANCELOT ANDREWES
Nineteen Sermons Concerning Prayer

*(Cambridge: printed by Roger Daniel,
Printer to the Universitie, 1641)*
BX 5037 A56N7 1641

Folio collections of seventeenth-century English sermons were produced for learned libraries, but smaller collections had their own functions. This one was evidently treated as a devotional volume, hence its elegant binding in richly gold-tooled black goatskin, with clasps. (These were most commonly used in the bindings of Bibles and books of devotion by the 1640s: Pearson 2005, 27–30.) The endpapers are printers' waste, in this case, blank sheets of paper onto which printed sheets have offset a faint mirror image of their text, a Latin poem from a Cambridge University collection on the peaceful return of Charles I from his journey to seek support in Scotland in the latter part of 1641 (*Irenodia Cantabrigiensis*, sig. F1v). An extract reads "Haud nosset unquam Roma, nec Anglia | Civile bellum, maxime Carole." Their author, James Duport, the professor of Greek, was not inspired with prophecy when he congratulated Charles I on his ability to avert civil war. The use of Cambridge printers' waste in the binding of a book printed in Cambridge suggests strongly that the binding was executed in that town. A bookseller there may have commissioned it in the knowledge that there would be purchasers willing to pay a good price for this book in such a binding, or it may have been personally commissioned. The earliest inscription in the book reads "Rebecka Rawlett her booke. 1649 | Wittnes. E. C." This owner may be the Rebecka Rawlet who was christened at St Mary Whitechapel, Stepney, on 1 June 1634, in which case she was fifteen when she acquired the book, and indeed, the witnessing of her ownership inscription suggests a schoolroom atmosphere. Later owners were Thomas Sandford, who dated his ownership inscription 1666; Katharine Green, who inscribed it twice in 1722 and again in 1727, "Th Green" (undated) and, finally, the Revd. W.S. Unwin, to whom it was given by H. Lindley on 23 February 1921. The first three have not been traced; the last, the Revd. William Sully Unwin (c. 1862–1943), was a distinguished university oarsman before his lifetime of service as a country clergyman (*The Times*, 13 August 1943, 7).

Retchel Rawle's her booke 1649

Thomas Sampson Rithu's P P
his booke 1669

Katharine Green
Her 1727 Book

Katharine Green Her

Book 1722

To Rev. W. S. Unwin
from H Lindley
Feb 23° 1921

DE
BELLO BELGICO.
THE
HISTORY
OF THE
Low-Countrey
WARRES.

Written in Latine *by*
FAMIANVS STRADA;
In English *by*
Sʳ. ROB. STAPYLTON Kᵗ.

Illustrated with divers Figures.

LONDON.
Printed for *Humphrey Moseley*, and are to be sold at
his shop at the signe of the *Princes Arms*
in St. *Pauls-Churchyard.*
MDCL.

(26)

FAMIANO STRADA

*De Bello Belgico: The History of the
Low-Countrey Warres* [part 1]

trans. SIR ROBERT STAPYLTON

(London: printed for Humphrey Mosley, 1650)

DH 186 s89 1650

This history of the Netherlands' Wars of
Independence, written in Latin by an Italian Jesuit
and originally published in 1632 with a second part
in 1647, must have seemed multiply topical to its
first English readers: the wars whose beginnings
it documented had only ended in 1648; England's
own civil wars had paused in 1648, and were
about to break out again; and hostilities between
England and the Netherlands were likewise about
to break out.

The first readers of this copy are well docu-
mented. Dorothea Drake (d. 1661), who signed
and dated the title page in February 1652, was
the wife of Sir Francis Drake of Buckland Abbey
(1617–62), great-nephew and heir of Sir Francis
Drake the circumnavigator. She was the daughter
of the parliamentarian John Pym, and would have
disagreed in political matters with the royalist
Stapylton — but Stapylton, publishing his trans-
lation in the year after the execution of Charles
I, was sensible enough to keep his own political
ideas out of it.

Did the book really belong to Dorothea or
Francis? When Sir Francis made his will on 10 April
1661, he bequeathed his books to his lawful heir,
namely his nephew Francis (1642–1717), with the
stipulation that Dorothea should have "the use of
my Italian and ffrench Bookes during her widow-
hood" (Fuller-Eliott-Drake 1911, 1:432). His library
is said by a later member of his family to have
included

> the works of Dante, Adriani, Boccaccio,
> Machiavelli, Guicciardini's History, Orlando
> Furioso, two large, finely illustrated volumes
> descriptive of the Roman catacombs, 'Les
> sentimens d'un honneste Homme' (much
> read and curiously initialled in several
> places by its owner), as well as a good many
> Italian novelli and the interminable French
> romances of Mlle. de Scuderi" (Fuller-Eliott-
> Drake 1911, 2:6).

This copy of Strada was signed and dated by Lady
Drake as if it were her personal property, with Sir
Francis' signature added as if he were a secondary
owner. At least one other book, a copy of the
English translation of Bodin's *République* trans-
lated in 1606 by Richard Knolles as *The Six Bookes
of a Commonweale*, which is now in the National
Library of Canada, is likewise inscribed on the
title page by both Dorothea and Francis Drake,
with a second signature of Dorothea's and that
of another member of the Drake family on the
last page (McRae 1962, A xi; additional informa-
tion kindly supplied by Elaine Hoag of Library and
Archives Canada).

(27)

SAMUEL FISHER

Rusticus ad Academicos

(London: printed for Robert Wilson, 1660)
BX 7730 F53 1660

This Quaker attack on traditional university learning was owned by John and Mary Vandewall, possibly brother and sister, shortly after it appeared in print. Ownership marks appear on the verso of the title page ("John Vandewall his Book 1661 | it Cost 6s6d"), on the first flyleaf ("John Vandewall" in a careful hand and, less carefully, "John Vandewall | And"), and on the following two front flyleaves (each of which records "Mary Vandewall owneth this Booke 1665"). The chronologically proximate dated ownership marks of John and Mary, as well as the "And," might suggest joint ownership of the book; cf. item 26.

Vandewall was the name of a Quaker family active in Essex after the Restoration. A Quaker named John Vandewall living in Harwich in the 1670s is recorded, for instance, as paying "foreigners fines" in Harwich in 1670 in order to bypass the oaths that were a precondition for certain trading rights but which Quakers refused as an article of their faith (Davies 2000, 208n86, 209n92). According to the Register of Burials for the Monthly Meeting of Colchester, Essex, John Vandewall of Harwich married Hannah More on 11 August 1669.

Mary Vandewall owneth this booke 1665

Lucy Weld

(28)

[SEVERIN SLÜTER]
Anatome logicae Rameae

(Frankfurt: apud D. Zachariam Palthenium, 1608)
Bound with Rudolph Snell, De ratione discendi
(Herborn: ex officina Christophori Corvini, 1599)
B 785 R43 S59 1608

Slüter's guide to the logical system of Petrus Ramus (Pierre de la Ramée) circulated very little outside German-speaking Europe: apart from the copy on display here, we know of one in the Bodleian Library, Oxford, one in the Staatsbibliothek zu Berlin, and one in each of the university or provincial libraries of Gotha, Göttingen, Hannover, Jena, Köln, and Rostock. The circulation of Snell's *De ratione discendi* seems to have been similarly restricted. This Sammelband, in a characteristic stiff German vellum binding stamped "M. H. V" at the top and "1607" at the bottom, evidently began its career near its places of publication. But a hundred years later, it was in the hands of a circle of students with Scottish names, probably in Ulster, as is suggested by the jotting "the right reverend | minister of ye gospel | at Cumber" (i.e. Comber, County Down) at page 64 of Snell.

We know several of their names (and that of the most recent private owner, Nicholas Wickenden, who generously gave it to the University of Alberta with other early modern books, including item 12 above). A Pat[rick]

Salmond inscribed the book without date, as did a Matthias Simpson (page 154 of Snell and first rear endpaper, verso); Robert Akine identified the book as his in 1702 (first front endpaper, recto); and an inscription dated 2 September 1713 begins by announcing that "David Russall est legitimus possesor huius libri empti | a Roberto Akine per Jacobi Russal &c: amen" (page 144 of Snell). This statement is followed by some lines of a hymn: "O moth[e]r dear Jerusalem when shall I come to ye" and "When shall I come to ye; | When shall | my sorowes | have ane end | Thay Joys | qn shall | I see" with the further note "Haec o[mn]ia | a me scrip= | =ta fuerit | Teste Gul: | Bresh[.]" The first three lines of the hymn appear again on page 154 of Snell. The hymn "O Mother, Dear Jerusalem" had been composed in the seventeenth century, and was attributed to the Scottish Presbyterian minister David Dickson (Miller 1869, 84–85). It was not widely available in print in 1713; was David Russall writing it down from memory, and does his writing it and having the writing witnessed suggest that he was a Presbyterian himself, one of a group for which it was particularly significant? Philosophy

schools for Nonconformists had been planned or founded at Comber and elsewhere in Ulster at the end of the seventeenth century (Greaves 1997, 246), and perhaps this book was used at such an institution: a school with limited funds, a long way from major book trade centres, where any textbook was welcome.

The pen trial elsewhere in the volume "f g h m tryes a good pen fghm Margrat Margarita | Interpone tuis interdum gaudia curis ut possis animo quemvis suffere laborem" (page 123 of Slüter) might possibly suggest a woman called Margaret as the writer, but it is likelier that her name was in the mind of a male writer, who went on from thinking about her to quoting the elementary school text called the *Disticha Catonis* to the effect that one must relax from one's labours from time to time.

The Mirrour of Princes, and Honour of Chivalry, PARISMUS; the most Renowned Prince of *Bohemia.*

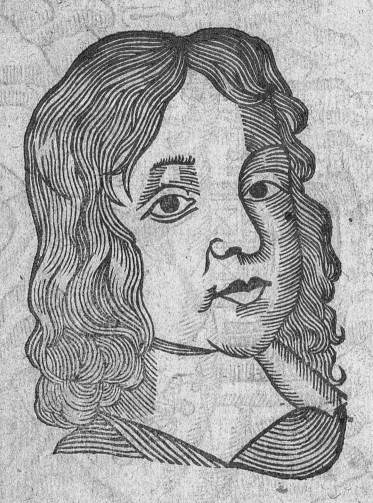

Lucy Weld

(29)

EMMANUEL FORD

The Most Famous, Delectable, and Pleasant History of Parismus, The Most Renowned Prince of Bohemia: The First Part, sixth impression

(London: printed by E[lizabeth] Alsop and Rob[ert] Wood, for Francis Grove and William Gilbertson, 1661)
PR 2276 F53 M92 1661

The prototypical reader of a romance like this one was sometimes assumed to be a woman of unsophisticated tastes (see e.g. Brayman Hackel 2005, 207f.), and the inscription of Lucy Weld at sig. A1r suggests just such a reader. But other inscriptions complicate the story. At the top of the preceding page is the inscription "Thomas Skingle owes this book | ita testatur | John Carter Coll: Sid: in Cambridge." This owner must have been the Thomas Skingle who was admitted to Sidney Sussex College, Cambridge, in 1670, the third son of a schoolmaster in Hackney. He was fifteen at the time. Was he the first owner of the book? It must have passed after his death in 1679 to the Thomas Skingley whose bold, flourished signature faces Lucy Weld's. Perhaps it then went to Weld, and then to Edmund Hill, whose inscription, dated 1 December 1746, is written sideways under "Thomas Skingle owes this book.". (Later still is the armorial bookplate of John Fish Pownall on the front pastedown; he was a nineteenth-century lawyer who doubtless owned the book for its antiquarian interest.) Whatever the sequence of provenance, the book was evidently owned and valued by a teenaged Cambridge undergraduate destined for Holy Orders in the Church of England.

(30)

LEWIS BAYLY

The Practice of Piety … The 36. Edition

*(Edinburgh: printed by the heires of
Andrew Hart, 1636)*

PR 3331 B36 1636

The gold-tooled initials "M B" on the mid- to late-seventeenth-century binding of this popular devotional handbook may have given rise to the supposition that this was the very book John Bunyan's first wife Mary brought to their marriage. Bunyan writes in *Grace Abounding to the Chief of Sinners*:

> This woman and I, though we came together as poor as poor might be (not having so much household stuff as a dish or a spoon betwixt us both), yet this she had for her part: The Plain Man's Pathway to Heaven and The Practice of Piety; which her father had left her when he died.

A modern note in the back of the book points out that a copy of *The Plain Mans Pathway* with Mary Bunyan's signature was burnt in George Offor's sale, "but it does not mention that the Practice of Pietie was!" George Offor owned a large collection of books, some of which were directly associated with Bunyan, which was to have been auctioned by Sotheby's in 1865. It included a 1625 octavo of Arthur Dent's *Plaine Man's Path-way to Heaven*, signed by "M. Bunyan" on the title page. The catalogue for this sale (Sotheby, Wilkinson, and Hodge 1865) also included copies of *The Practice of Pietie*, one printed in Dublin in 1701, another printed in Delft. So the University of Alberta copy is unlikely to have either survived the saleroom fire or been owned by Mary Bunyan. What is perhaps more remarkable about this volume is the faded and seemingly anguished prayer for a guilty conscience written out at the end of the volume, displayed here, beginning: "Most merrci.fulle most loving | and dier foothir: I poore distressed | sinner bē[ing] disturbett in mynd trubld | in conscience …." Prayers or poems copied into books are usually not original. The idiosyncratic spelling suggests that the writer composed this prayer him or herself, rather than copying it from elsewhere, and that she or he was only modestly educated.

Receive mee then into that most joyfull Paradise, which thou didest promise unto the penitent thief, which at his last gaspe upon the crosse, so devoutly begged thy mercie and admission into thy kingdome. Grant this, O Christ, for thine own names sake: To whom (as it is most due) I ascribe all glory and honour, praise and dominion, both now and for ever.

Amen.

FINIS.

𝕰nter into thy 𝕮loſet:

OR, A

METHOD

John and Bunyan

ORDER

his FOR PRIVATE *Booke*

DEVOTION.

16 Bedford 78

WITH

AN APPENDIX

Concerning the Frequent and Holy Uſe

OF THE

LORDS SUPPER.

𝕿hird 𝕰dition.

Zech. 3. 2. *Is not this a brand pluckt out of the fire?*

London, Printed for *John Martyn*, and are to be ſold at the *Bell* a little without *Temple-Bar*, 1670.

(31)

EDWARD WETENHALL

Enter into Thy Closet; or, A Method and Order for Private Devotion

(London: printed for John Martyn, 1670)
BV 4831 W53 1670

A hunger for Bunyaniana likely produced the ownership inscription here displayed; it is certainly a fake, looking nothing like specimens of Bunyan's known signature and appearing to have been written with a metal nib rather than a trimmed quill. It also seems doubtful that the Nonconformist Bunyan would have been sympathetic to this devotional work by a man who was to become bishop of Kilmore and Ardagh in the Church of Ireland, especially as it includes a lengthy appendix urging the reader to take frequent communion in the Established Church, "private devotion" not having been designed as a way out but to "prepare us for the publick worship of God" (327–28).

Synce Celia's my foe to some

Where some River for euer

the Trees will appeare more re

In y.e Morning Adorning each leaf

When I make my sad moane soy

from each hallow will follow

Then Celia Adieu synce I leau

y'oul Discouer noe Louer was

yo.r sad shepheard flyes from this

Where not seeing his being Decay

It is better to runn to y.e fate

Then for her to Endeavour what

What you God haue I done t

should bee hated and slighted fo

what you God, y

(32)

EDMUND SPENSER
The Shepheards Calendar

> (London: printed by H[umphrey] L[ownes]
> for Mathew Lownes, 1611)
> PR 2359 A1 1611

This copy of Spenser's eclogues evidently fell into the hands of children, perhaps because it was one of the few illustrated books in a household collection, but it had grown-up annotators as well. So, for instance, the woodcut illustrating the eclogue for April has been partially coloured in by a child, but an older reader has noted that the word "make" is used on this page in the sense "compose poetry," in imitation of one of the senses of the Greek word ποιειν, and has underlined it and provided the Greek. The opening displayed here shows an adult note; the eclogue for June is said to have been "composed after yᵉ death of Sʳ Phil. Sidney. 9. J." The annotator must have believed that the line "The God of Shepheards TITYRUS is dead" at the top of the right-hand column of page 27 refers to Sidney, though the identification of Tityrus with Chaucer is made explicit in the printed commentary on page 29. We cannot explain the characters "9. J." which follow the note.

THis Aeglogu
cesse in his lou
Lasse, *Rosalinde*, a
teth to his deere fr
in his stead, *Mena*
the whole Argum

H

LO COLIN, heere the pla
From other shades hath we
Tell me, what wants mee
The simple aire, the gentle warb
So calme, so coole, as no where e
The grassie ground with daintie

IVNE.

Aegloga sexta. composed after ye death of Sr
phil. Sidney, 9.T.

ARGVMENT.

ollie vowed to the complaining of *Collins* ill suc-
r beeing (as is aforesaid) enamoured of a countrey
uing (as seemeth) found place in her heart, he lamen-
Iobbinoll, that he is now forsaken vnfaithfully, and
other shepheard receiued disloyallie. And this is
this Aeglogue.

NOLL.	COLIN CLOVT.
ose pleasant sight	And to the dales resort, where shepheards ritch,
wandring mind:	And fruitful flocks been euery where to see:
worke delight?	Heere no night Rauens lodge, more black then pitch,
d,	Nor eluish ghosts, nor gastly Owles doe flee.
d:	
light,	But friendly Faeries, met with many Graces,

45

Hence-forth sir Knight, take to you wonted strength,
And maister these mishaps with patient might;
Lo, where your foe lyes stretcht in monstrous length:
And lo, that wicked woman in your sight,
The roote of all your care, and wretched plight,
Now in your powre, to let her liue, or die.
To doe her die (quoth *Vna*) were despight,
And shame t'auenge so weake an enemy;
But spoile her of her scarlet robe, and let her fly.

46

So, as she bade, that Witch they disarraid,
And robd of royall robes, and purple pall,
And ornaments that richly were displaid;
Ne spared they to strip her naked all.
Then when they had despoyld her tire and Call,
Such as she was, their eyes might her behold,
That her misshaped parts did them appall,
A loathly, wrinkled hag, ill fauour'd, old,
Whose secret filth, good manners biddeth not be told.

47

Her crafty head was altogether bald,
And (as in hate of honourable eld)
Was ouer-growne with scurfe and filthy scald;
Her teeth out of her rotten gummes were feld,
And her sowre breath abhominably smeld;
Her dried dugs, like bladders lacking wind,
Hung downe, and filthy matter from them weld;
Her writhled skin, as rough as Maple rind,
So scabby was, that would haue loath'd all womankind.

48

Her nether parts, the shame of all her kind,
My chaster Muse for shame doth blush to write:
But at her rompe she growing had behind
A Foxes taile, with dung all fouly dight;
And eke her feet most monstrous were in sight;
For one of them was like an Eagles claw,
With griping talons armd to greedy fight,
The other like a Beares vneuen paw:
More vgly shape yet neuer liuing creature saw.

49

Which when the knights beheld, amaz'd they were,
And wondred at so foule deformed wight.
Such then (said *Vna*) as shee seemeth here,
Such is the face of Falshood, such the sight
Of foule *Duessa*, when her borrowed light
Is layd away, and counterfesaunce knowne.
Thus when they had the Witch disrobed quight,
And all her filthy feature open showne,
They let her goe at will, and wander waies vnknowne.

50

She flying fast from heauens hated face,
And from the world that her discouer'd wide,
Fled to the wastfull wildernesse apace,
From liuing eyes her open shame to hide,
And lurkt in rocks and Caues long vnespide.
But that faire crew of knights, and *Vna* faire,
Did in that Castle afterwards abide,
To rest themselues, and wearie powres repaire,
Where store they found of all, that dainty was and rare.

Canto IX.

His loues and linage Arthur tells,
the knights knit friendly bands:
Sir Treuisan flies from Despaire,
whom Redcrosse knight withstands.

1

O Goodly golden chaine, where-with yfere
The vertues linked are in louely wise;
And noble minds of yore allied were,
In braue pursuit of cheualrous emprise,
That none did others safety despise,
Nor aide envie to him in need that stands,
But friendly each did others praise deuise,
How to advance with fauourable hands, (bands.
As this good Prince redoemd the *Redcrosse* knight from

2

Who when their powres, empaird through labour long,
With due repast they had recured well,
And that weake captiue wight now wexed strong,
Them list no lenger there at leysure dwell,
But forward fare, as their adventures fell:
But ere they parted, *Vna* faire besought
That stranger knight his name and nation tell;
Least so great good, as he for her had wrought,
Should die vnknowne, and buried be in thanklesse thought.

Faire

(33)

EDMUND SPENSER

The Faerie Queen

(London: printed by H[umphrey] L[ownes]
for Mathew Lownes, 1617)
PR 2350 1617

The association between Spenser and the endur-
ingly glamorous Sir Philip Sidney is made here
as it was in item 32. A marginal note remarks at
the beginning of Book I, Canto IX that "This is
the Canto yt Spenser at his first going to Court,
presented to Sr Phil. Sidney." The same hand has
noted Spenser's birth and death dates, as well as
a quotation from Ovid's *Metamorphoses* on the
verso of the title page; this is perhaps the same
hand that declares the book to belong to "Tho.
Hayward | Warrington" (and adds a leash to the
porcupine that adorns the title page). The Rev.
Thomas Hayward (d. 1757) was curate of St Mary's,
Great Sankey, near the Cheshire-Lancashire border,
and headmaster of Boteler Grammar School in
nearby Warrington.

Hayward, if it was he, got his story about
Sidney's response to this particular canto from
the biographical introduction to the 1679 *Works*
of Spenser, which reports that the poet "took an
occasion to go one morning to *Leicester-House*,

furnish't only with a modest confidence, and the
Ninth *Canto* of the First Book of his *Faëry Queen*"
(Garrett 1996, 265; cf. ibid., 48–50); the story
goes on to have Sidney reward him with princely
generosity.

(34)

PHILIP SIDNEY

The Countesse of Pembroke's Arcadia

(London: printed [by Thomas Harper and Robert Young]
for J[ohn] Waterson and R[obert] Young, 1638)
PR 2342 C85 1638

Early editions of Sidney's *Arcadia* were often anno-
tated (Brayman Hackel 2005, 158–75). This copy of
the 1638 edition, printed in part by Thomas Harper
(see item 4), is signed on the title page by a seven-
teenth-century reader called Jonathan Kinge, who
paid ten shillings for it. Kinge also signed the first
of the rear endpapers, and wrote verses begin-
ning "ffortune did neuer in one day design | for any
heart, fower torm[en]ts great as mine" under his
signature, and verses beginning "He who can all
his loue contayne in words" on the next endpaper,
which is displayed here; they are all from the third
act of Roger Boyle's drama *Mustapha* of 1668. The
latter verses were then recopied in a different
hand, that of Charles Mounteney, whose bold
signature follows. A man of this name appears on
a list of shareholders in the East India Company in
1684. Under his signature, in what appears to be
his hand, is a third set of verses, beginning "Synce
Celia's my foe to some Desert Ille goe"; these are
the opening lines of Thomas Duffett's "Amintor's
Lamentation," published as a broadside ballad
in 1676.

He who can all his loue contayne in words
Has such a heart as little loue affords.

Louers high thoughts to wonders are inclined
And boundless thoughts sute not with speech confind

Hee who cann all his loue conteyne in words
Has such a heart as little loue affords
Louers high thoughts to wonders are Inclin'd
And boundless thoughts sute not with speech confin

Charles Mounteney

Synce Celia's my foe to some Desert Ile goe.
Where some Riuer for Euer shall Echoe my Woe
The Trees will appeare more relenting then sho
In ye Morning Adorning each leafe with a teare
When I make my sad moane toy Rocks all alone
From each hollow will follow some pittifull Groane
Then Celia Adieu synce I Ceafe to pursue
y'oul Discouer noe louer was euer soe true
yor sad shepheard flyys from those deare Cruell Eyys
Where not seeing his being Decayys & hee Dyys
It is better to rum to yo fate wee Cannot Shunn
Then for Euer to Endeauour what cannot bee wonne
What you Gods haue I Done that Amyntas alone
should bee hated and slighted for Loueing but one
What you Gods &c

(35)

JEREMY TAYLOR

The Rule and Exercises of Holy Living

(London: printed by Roger Norton, 1674). Bound with
Jeremy Taylor, The Rule and Exercises of Holy Dying
(London: printed by R[oger] Norton for R[ichard]
Royston, 1674)
BV 4500 T242 1674

A chaplain to William Laud and Charles I, Taylor
wrote his most popular works, *Holy Living* and *Holy
Dying*, after a spell of imprisonment and while in
retirement in the early 1650s. At the Restoration,
he became a bishop in the Church of Ireland. This
title page of *Holy Living* was signed by Anne Dewy.
The verso of the final printed page of *Holy Dying*,
here displayed, records her death on 13 May 1724, as
well as the deaths of three other persons — James
Davis, Sarah Story, and Ann Davis — between 1725
and 1730. Generally, the book is unmarked, but
at one point a reader has substituted the more
reverent "O" in a prayer beginning "dear God" (37).

Ann Deny died ma[y]
y^e 13 1724

James Davis died
March y^e 15 1724/5

Sarah Story died Decem[ber]
y^e 18 1725

Ann Davis died ma[r]
y^e 29 1730

William Kynaston

of Bronington in the County of fflint borne
March the 26 mane. And marryed to Katherine
the daughter of Rose Clabb widd: of ffarndon
in the County of Chester Jan 30th in the 29th year

Ano do: 1664/5 of his age

An: do: 1665/6 On munday the 15th of January J had a Son born
about 42 minutes after 12 of the clock at noon An: Do
was baptised by the name of Thomas on ffebr: 15 afternoon
 witnesses wer

Anno 1667 John my Second Son borne upon the 24th of Mr Barn
December about a quarter past 9 of the Clock at Mr Stri
night. An: dom: 1667 was baptized by mr Marlor the 29 of Mr Marl
following: Witnesse Tho: Vaughan
 Edw: Kynaston
 Eliz: Kynaston

At midsumer 1669 Jack weaned (Tom began to learn)
 and to read May 9th 1670.

Ano 1670 William my third Son born October the 24th about 6 minutes be
3 of the Clock in the morning being munday morning. Baptized by m
Novemb 5th following witnesses John Evaston
 John Johnson
 Rose Clubb

4
85
5/6
6/3
87
88
89
90

(36)

RICHARD BAXTER

Plain Scripture Proof of Infants Church-Membership and Baptism

(London: printed for R[obert] White, 1651)
PR 3316 B36 P6 1651

William Kynaston, of Bronington in the county of Flint in northeast Wales, used this edition of Baxter's *Plain Scripture Proof* to record, down to the minute, details of the births of his three sons, with other family information such as the dates of his second son's weaning and his eldest beginning to be instructed and to read ("At midsum[m]er 1669 Jack weaned & Tom began to learn | and to read May 9th 1670"). It has not yet been possible to verify this exceptionally detailed information against official records, perhaps because the family were Nonconformists? Religious nonconformity is certainly one reason not to show up in parish records, and perhaps also explains the exceptionally detailed records of baptisms, with witnesses. These Kynastons do not appear in non-parochial registers either, however. The first son, who also signed his name and the date '83 on the front flyleaf, is the right age and in the right part of the British Isles to be Thomas Kynaston, first minister of a newly established Nonconformist chapel at Brook Street, Knutsford, Cheshire. (He was successor to the more famous Presbyterian William Tong, who first preached to this congregation in rented houses.) Thomas Kynaston died in 1695, aged about 29, having been pastor of the congregation for six years. His grave was the first in the chapel's new graveyard.

(37)

RICHARD BAXTER

The Saints Everlasting Rest: or, A Treatise of the Blessed State of the Saints in their Enjoyment of God in Glory

(London: printed by R[obert] White for T[homas] Underhill and F[rancis] Tyton, 1650)

BV 4831 B35

A reader has written "marke" several times throughout this tome, once near a passage arguing that true conversion is achieved through "rational perswading" rather than "compelling men to profess ... by the sword" (223). The sentiment itself is typical of Richard Baxter, a Presbyterian minister and prolific writer known for his interest in the irenical resolution of religious differences. Like Jeremy Taylor (see item 35), he used enforced leisure to write devotional works, his very popular *Saints Everlasting Rest* having been "Written by the author for his own use, in the time of his languishing, when God took him off from all publike imployment." The opening displayed shows a reader's response to a passage on "the torments of the damned" which recommends testing "whether thou canst endure the fire of Hell" by sticking a finger in a candle, as the martyr Thomas Bilney did according to Foxe's *Actes and Monuments*, a woodcut in which shows his experiment (Foxe 1563, sig. Vv7v). The reader judges this "a very good hint," but whether she or he put the hint into practice cannot be known.

en the Phyſitian hath plainly told thee that
cold it ſtrikes to thy heart ? VVhy is death
rs elſe ? and the ſtouteſt champions then do
but the grave would be accounted a palace
on of that place of Torment which thou

ing, go try thy ſtrength by ſome corporall
re he went to the ſtake, would firſt try his
thou; Hold thy finger a while in the fire, and
canſt endure the fire of Hell : *Auſtin* men-
voman who being tempted to uncleanneſs by
ſireth him for her ſake to hold his finger an
vereth, It is an unreaſonable requeſt; How
e is it (ſaith ſhe) that I ſhould burn in Hell
r luſt ? Lo ſay I to thee : If it be an intoller-
eat of the fire for a yeer, or a day, or an hour,
ten thouſand times more for ever ? VVhat
wrence his death, to be roſted upon a Grid-
r pricked to death as other Martyrs were ?
d upon toads for a yeer together ? If thou
things as theſe, how wilt thou endure the e-

f Hell be ſo ſmall a matter, why canſt thou not
oughts or the mention of it ? If thou be alone,
k of Hel, for fear of raiſing diſquietneſs in thy
any, thou canſt not endure to have any ſerious
e the ſport and mar the mirth, and make thee
en *Paul* was diſcourſing of the Judgement to
ndure to hear a Miniſter preach of Hell, but
and diſdaineſt him, and reproacheſt his Ser-
men to deſperation or make them mad. And
rments, when thou canſt not endure ſo much
, man, to hear thy Judgment from the mouth
execution, will be another kinde of matter
iniſter.

t is the matter that the rich man in Hell men-
d not make as light of it as thou doſt ? VVas
bear it as thy ſelf ? VVhy doth he ſo cry out
n the flames ? and ſtoop ſo low as to beg a
drop

drop of water of a beggar that he had but a little before deſpiſed at his gates ? and to be beholden to him that had been beholden to the dogs to lick his ſores ?

8. Alſo what aileth thy companions who were as reſolute as thy ſelf, that when they lye a dying their courage is ſo cooled, and their haughty expreſſions are ſo greatly changed ? They who had the ſame ſpirits and language as thou haſt now, and made as light of all the threats of the word, yet when they ſee they are going into another world, how pale do they look? how faintly do they ſpeak? how dole-fully do they complain and groan ? They ſend for the Miniſter then, whom they deſpiſed before, and deſire to be prayed for, and would be glad to dye in the ſtate of thoſe, whom they would not be perſwad-ed to imitate in their lives. Except it be here and there a deſperate wretch, who is given over to a more then Helliſh hardneſs of heart. VVhy cannot theſe make as light of it as thou ?

9. Yet further, if thou be ſo fearleſs of that eternall miſery, why is the leaſt foretaſt of it ſo terrible? Didſt thou never feel ſuch a thing as a tormenting conſcience ? If thou haſt not, thou ſhalt do. Didſt thou never ſee and ſpeak with a man that lived in deſparation ? or in ſome degree of theſe wounds of ſpirit, that was neer deſpair ? How uncomfortable was their conference ? How burdenſome their lives ? Nothing doth them good which they poſſeſſe ; The ſight of friends, or houſe, or goods which refreſh others, is a trouble to them: They feel no ſweetneſs in meat or drink : They are weary of life, and fearful of death : VVhat is the matter with theſe men ? If the Miſery of the damned it ſelf can be endured, why cannot they more eaſily endure theſe little ſparks ?

10. Again, tell me faithfully ; VVhat if thou ſhouldeſt but ſee the Devil appear to thee in ſome terrible ſhape ? VVould it not daunt thee? VVhat if thou ſhouldeſt meet him in thy way home ? Or he ſhould ſhew himſelf to thee at night in thy bed-chamber ? would not thy heart faile thee ? and thy hair ſtand an end ? I could name thee thoſe that have been as confident as thy ſelf, who by ſuch a ſight have been ſo appaled, that they were in danger of being driven out of their wits. Or what if ſome damned ſoul of thy former acquaintance ſhould appear to thee in ſome bodily likeneſs? Would not this amaze thee ? VVhat fears do people live in, whoſe houſes or perſons have been but haunted with ſpirits ? Though they have only heard ſome noiſes, and ſeen ſome ſights, but never felt any hurt upon their bodies?

Lord shall I suffer these? and withall should hear thee praying against death; can he believe thy tongue agrees with thy heart? except thou have so far lost thy reason, as to expect all this here; or except the Papists Doctrine were true, that we are able to fulfil the Law of God; or our late Perfectionists are truly enlightned, who think they can live and not sin: but if thou know these to be undoubtedly false, how canst thou deny thy gross dissembling?

think of often SECT. VIII.

* How oft hath
it been revea-
led to me, that
I should daily
preach and
publiquely
contest, that
our Brethren
are not to be
lamented,
who are deli-

7. COnsider, * how do we wrong the Lord and his Promises? and disgrace his wayes in the eyes of the world? As if we would actually perswade them to question, whether God be true of his Word or no? whether there be any such glory as Scripture mentions? when they see those who have professed to live by Faith, and have boasted of their hopes in another world, and perswaded others to let go all for these hopes, and spoken disgracefully of all things below, in comparison of these unexpressible vered from this world by the Call of God? when we know that they are not lost, but sent before? Departing they lead us the way, as Travellers and Saylers use to do; that They may be Desired, but not bewayled! and that we should not put on black cloaths for them here, when they have put on white rayment there?that we should give the Heathen occasion justly to reprehend us, that we lament those as Dead and lost, whom we affirm to be with God:and that we condemn that faith by the testimony of our hearts, which we profess by the testimony of our Speech. We are prevaricators of our faith and hope: and make that which we teach seem to them counterfeit, feigned and dissembled. It will do us no good to prefer Virtue in words, and destroy verity by our Deeds. *Cyprian. de Mortalitate.* Sect. 14. pag. (*mihi*) 345.

things

(38)

RICHARD BAXTER

Saints Everlasting Rest

(London : printed for Thomas Underhill
and Francis Tyton, 1651)

BV 4831 B35 1651

The University of Alberta owns five copies of Baxter's immensely popular *Saints Everlasting Rest* from the first decade of its publication, dated 1650, 1651, 1653, 1658, and 1659. This 1651 edition is the most scribbled upon, containing marks to help the reader internalize the text, as in "think of often." It also contains the names (sometimes multiply signed) of nine people throughout: John Heywood (1690), Sarah Long, John Jackson, "James Birch of Manchester" (1727/8), James Corbet (1764), John Wayne (with a date perhaps in the 1800s), Robert Ray, William Wrays (1821, "Given by his Father on

the 25th of Dec"), and finally, the quite modern hand of "James Rayes Hasland Rd." Like Bunyan, Baxter remained a popular household resource for at least two centuries after the first publication of his books. (In fiction, Mrs Glegg of George Eliot's *Mill on the Floss* turns to the *Saints Everlasting Rest* in moments of domestic crisis.) The opening displayed here preserves something other than pen marks, however, and shows a different use for this heavy book: the preserved petals of a flower, perhaps a tulip.

OLY WARRE

By

THOMAS FULLER,

D. Prebendarie of *Sarum*, late of *Sidney*

Colledge in CAMBRIDGE.

The second edition.

(39)

THOMAS FULLER

The Historie of the Holy Warre

*(Cambridge: printed by R[oger] Daniel
for Thomas Buck, 1640)*
D 158 F96 1640

Inscribed on the title page are the names, in
immature but apparently contemporaneous
hands, of "Hen. Goodricke" and "Jane Goodricke[.]"
They are very probably to be identified with two
of the children of Sir Henry Goodricke, Bart. (1677–
1738), namely Henry, one of his younger sons (b.
after 1708), and Jane (c.1718–88), who married
Francis Wanley, dean of Ripon (Fowler 1884, 274).
They were, as *ODNB*'s notice of their elder brother
Sir John puts it, brought up "within an atmos-
phere of physical and spiritual well-being where
books and polite conversation abounded," this
being evidently one of the books. The book may
have passed directly from the Goodricke family to
its later owner, the poet and book collector Francis
Wrangham (1769–1842), whose signature, dated
1813, is at the top of the title page.

THE HISTORIE
of the
HOLY WARRE;

By
THOMAS FULLER,
B. D. Prebendarie of *Sarum*, late of *Sidney*
Colledge in CAMBRIDGE.

The second edition.

CAMBRIDGE,
Printed by R. DANIEL, for THOMAS BUCK,
and are to be sold by JOHN WILLIAMS
at the signe of the Greyhound in PAULS
CHURCH-YARD. 1640.

Hill & Church
Lane Commercial Road

1 June 1820

Sarianna Browning

(40)

THOMAS FULLER

The Historie of the Holy Warre

*(Cambridge: printed by Roger Daniel, and are
to be sold by John Williams, 1647)*
D 158 F96 1647

This copy is inscribed "S. Hill 6 Church | lane Commercial Road | 1 June 1820" on the recto of first endpaper, and under this, "Sarianna Browning[.]" S. Hill has not been identified, and does not appear to have owned other books in the Browning family's collections; he or she may have been connected with the (Baptist) Beulah Chapel which was located on Church Lane until 1821 and then moved to the Commercial Road. Sarianna Browning (1814–1903) was the sister of the poet Robert Browning, and the book was added to his collection at some point, for on the front pastedown is the printed label "FROM THE LIBRARY | OF THE LATE | ROBERT BROWNING[.]" This label was almost certainly printed for the book dealer Howell of London, who purchased forty lots at the auction sale of Browning's books in 1913, among which this book must have been (though it did not have its own entry in the sale catalogue); there are four copies of the label on books now at the Armstrong Browning Library of Baylor University in Texas, and four on books in other collections, and in every case the book was bought by Howell at the 1913 sale. (The books at Baylor are Kelley and Coley 1984, entries A644, A839, A1127,

A1649. Those in other collections are ibid., A646, at Yale; A764, present location unknown; A1259, at Texas; A1505, in the Berg Collection of the New York Public Library. The University of Alberta copy of the *Holy Warre* is ibid., A1006.) Posthumous labels of this sort were added by nineteenth-century and later dealers to books from the libraries of other famous persons, for instance Dickens (Lee 1981, 64–5). *We are very grateful to Cynthia Burgess of the Armstrong Browning Library for her help with this entry.*

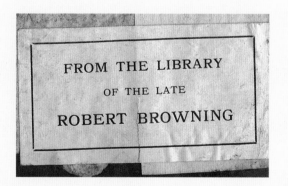

(41)

THOMAS FULLER
Historie of the Holy Warre ed. 4

*([Cambridge]: printed by Thomas Buck, one of the
printers to the Universitie, and are to be sold by
Philemon Stephens, 1651)
Bound with* idem, The Holy State ed. 4 *(London:
printed by John Redmayne for John Williams, 1663)
D 158 F96 1651*

This copy has the ownership inscription of
Thomas Bowber sideways on its rear endpaper.
This member of the non-armigerous Devon
family of Bowber was very probably Thomas
Bowber (c.1663–1732?), son of Robert Bowber of
Sandwell, Devon. He matriculated at Wadham
College, Oxford, in 1680 as a poor man's son, "fil.
... pauperis," received his BA in 1684 and took Holy
Orders, preached a sermon on the death of Queen
Mary at St Swithin's Church, London, in 1695, and
served as vicar of Felmersham in Bedfordshire
from 1712 to 1732 (Gardiner 1889, 328; Genuki). The
living of Felmersham was valued at forty pounds
a year in 1711, making it one of the better ones in
north Bedfordshire, though by no means princely
(Ecton 1711, 192). It is perhaps not fanciful to see
the vicar of such a living as rich enough to afford
substantial books like *Holy Warre* and *Holy State*,
but as poor enough to own them in the present
somewhat bulky volume rather than in more

expensive separate bindings. If that was Bowber's
case, he appears not to have been alone. Although
these two books were not written as a pair, they
were bound together by other early owners. Two
such volumes have appeared on the market in the
first decade of the twenty-first century: one unites
the same editions of the *Holy Warre* and *Holy State*
as this copy (Gray 2005, item 132d), and the other
unites the 1647 *Holy Warre* and the 1648 *Holy State*
(Middleton 2009).

Thomas Bowbier

drawing on (the
ftermoone wee had a
iffioners are thefe :
th, Sir Richard
ours are, Colonell
ht, and Lieutenant
igh, but they de-
urtefs ; To morrow
aine, and we doubt
tions : Scarborough
reaty : our Scouts
rs for intelligence
have found about
which as is concei-
ffect of War is va-
yefterday morning
Newarkers by the
the guard : it is
away their plunder.
Major Generalls
them. The fick-
gure, which make
y in the Caftle, it
I pray God remove
ke 26 Beafts from
vors of the enemy

fome of the Commiffioner.
render of Scarborough Ca
the next.

Saturday, July 19. The
ing the inftructions for the
in the Scottifh army.

This evening Lieutenam
Sergeant at armes at Weft

POLITICAL ANNOTATIONS

falfe and fcandalous words
honorable houfe of Comme
knowne, and upon whom
well that men would be car
imployed in the affaires of
e... the grounds upon
difhonour : leaft they be
Let thofe that are unfaithfu
and fincere what greater in
away their good names.

For the commitment o
votes of the houfe againft
already.

Munday, July 21. A peti
prifoner in Newgate was re
done thereupon.

This day there were feve
mons from Sir Thomas F.
particulars whereof were

That Sir Tho. Fairfax f
ving them alarms day and
above 30 pieces of Ordnan
32. pound bullet, the Town
befides the benefit of the ti
Townefmen therein. Out
to ftorme it every day. H

(42)

S[AMUEL] D[ANIEL]

The Collection of the History of England

(London: printed for Simon Waterson, 1626)

DA 130 D 18

This historical compendium has some long notes at the beginning and end, most strikingly a poem with comments on the blank recto of the first leaf (the royal privilege is on the verso). The poem begins

> Christ roade some seauen yeares since
> to Court
> And ther hee lefte his Asse
> The Courtiours kickt him out of doores
> Because ther was noe grasse

and continues with the ass's complaint, and his report of his master's prophecy that in 1643 "Nothinge at all within that Court | But only grasse shall bee" and that then, one "will not giue that Asse for all | The Horses in the Mewes." The comment below, evidently written in the 1640s or 1650s, is

> These were made (as I haue heard) by one Williams a Barrister of the Temple | and for which he was executed at Charinge Crosse in May 1619. Of | whose execution ther is mention in S[r] Rich: Bakers English history in the | life of Kinge James, and the offence

ther sayd to bee ffor ciuillinge | and writeing bookes against the Kinge. Howsoever wee haue liued to see | Whitehall Court a grasse platt, and the Mewes for diuerse since yeares, | wthout any horse of the Kings./

This quotes Sir Richard Baker's *Chronicle* from the first edition, that of 1643 (at page 143 in the last sequence of pagination); the 1653 edition (page 606) has *libelling* for the meaningless *civilling*. There are two copies of this poem in Bodleian manuscripts: MS Malone 19, which is endorsed "Verses found in a box sealed, found at the Court, & delivered to the kinge" and dated 30 September 1621, and MS Rawlinson Poet. 26, which also copies prophecies by John Williams (Crum 1969, c260; Marotti 1995, 15). Williams came from Brentwood, and married a daughter of Sir Jerome Weston in 1590. He was expelled from the Middle Temple for Popish recusancy in 1612, and was executed for foretelling the death of the king in the libel "Balaam's Ass" (Waters 1878, 1:96–97).

Christ roade some seaven dayes sence to Court
And there he lette his Asse.
The Courtiers kickt him out of doores
Because there was noe grasse.

The Beast went mourninge vp & downe
And thus I heard him bray
Although that time they had noe grasse
They might haue giuen him hay.

But now my Maister saith the time
Is come that men shall see
Nothinge at all within that Court
But only grasse shall bee.

The time is come my Maister saide)
But yet as he told mee
The effect thereof before that time
I speake of shall not bee.

In 1000, 600, 43,
The last day of September
Let him that soe despised that Asse
That Asses wordes remember.

Or if not then, before the ides
Of March that next ensues
Hee will not giue that Asse for all
The Horses in the Mewes.

These were made (as I haue heard) by one Williams a Barrister of the Temple and for which he was executed at Charinge Crosse in May 1619. Of whose execution there is mention in Sr Rich: Baker's English history in the life of Kinge James and his offence there sayd to bee ffor ticuillinge and writeing bookes against the Kinge. Howsoever wee haue liued to see Whitehall Court a grasse platt and the Mewes for diuerse yeares, without any horse of the Kings.

before Pontefract and in other parts, I will here communicate the same for more ample satisfaction:

WHat I have weekely hoped for is now drawing on (the surrender of this Castle) for this afternoone wee had a parley with the enemy in it : Their Commissioners are these : Sir Iohn Ramsden, Sir Geo. Wentworth, Sir Richard Hutton, and Lieutenant Col. Galbreth : ours are, Colonell Wastell, Colonell Copley, Colonell Bright, and Lieutenant Colonell Fairfax, their termes are very high, but they de∣meane themselves with much civility and courtesie; To morrow morning at nine a clock we are to meete againe, and we doubt not but they will imbrace honourable conditions : Scarborough is still in the same posture drawing to a Treaty : our Scouts have of late taken many considerable Members for intelligence betweene Newarke and Pontefract, and have found about them letters written in obscure characters, which as is concei∣ved are of great concernment. And as the effect of War is va∣rious, this weeke affords us a mixture : yesterday morning Welbeck house was unhappily surprized by the Newarkers by the treachery of a Corporall of ours then upon the guard : it is thought they will not hold it since they send away their plunder. Skipton Castle is blockt up with some of our Major Generalls forces, and more are to be sent thither unto them. The sick∣nesse is suspected to be amongst us in this league, which make us the more willing to treat with the enemy in the Castle, it raignes in many other Townes in these parts, I pray God remove it. This morning some of our forces tooke 26 Beasts from the enemy belonging unto Sandall Castle, divers of the enemy were taken prisoners and others killed:

Pontefract league
July 18. 1645.

By other letters dated from York 15 instant it is certified, That the enemies forces in Rabi-Castle, have not provisions to hold out above ten dayes longer, and by that time at farthest a surrender is expected : That——Letters came from Sir Hugh Cholmely to some of the Commissioners there, concerning a Treaty for sur∣render of Scarborough Castle, of which you will here further by the next.

Saturday, Iuly 19. The house of Peeres had a debate concern∣ing the instructions for the Commissioners that are to goe to reside in the Scottish army.

This evening Lieutenant Colonell Lilborne was arrested by the Sergeant at armes at Westminster-hall-gate, for reporting some false and scandalous words concerning a worthy Member of the honorable house of Commons, whose integrity and fidelity is well knowne, and upon whom no blemish could as yet fasten; it were well that men would be carefull how they traduce those, who are imployed in the affaires of the Commonwealth, and especially to examine the grounds upon which they report any thing to their dishonour : least they be made exemplary and severly punished. Let those that are unfaithfull suffer, but for those that are upright and sincere what greater injury can be done unto them then to take away their good names.

For the commitment of Mr. Cranford to the Tower, and the votes of the house against him I omit them, you have had them already.

Munday, July 21. A petition presented from Prince Griffith now prisoner in Newgate was read in the house of peeres, but nothing done thereupon.

This day there were severall letters read in the house of Com∣mons from Sir Thomas Fairfax his army before Bridgewater the particulars whereof were as followeth.

That Sir Tho. Fairfax still continued before Bridgewater, gi∣ving them alarms day and night. That there was in the Towne above 30 pieces of Ordnance, one Demy-cannon, another carries a 32. pound bullet, the Towne strongly fortified with deep trenches, besides the benefit of the tides, about 1000. souldiers, Welsh and Townesmen therein. Our souldiers have their Bavins, and expect so storme it every day. However it is conceived a few daies will starve

Vvvvv 2

(43)

Mercurius Civicus: Londons Intelligencer
or Truth Impartially Related from Thence
to the Whole Kingdome, to Prevent
Mis-Information, **Number 113**

(17 June to 14 July 1645)
DA 411 M55

The University of Alberta owns a small run of newsbooks dating from the period of the English civil wars, all annotated copiously in the same contemporary hand: these are marks of someone acting on the news as it happens, with a pen. A number of the annotations cross-reference items to an evidently much larger collection of news-books. Some simply repeat crucial facts in the margins, such as the numbers of foot or horse, or mark the region from which the news comes, as "London," "Ireland," etc. A recurring marginal note, "sent," suggests that this collector and annotator of newsbooks was also a gatherer and distributor of personalized newsletters. He or she seems to have been a Royalist, judging from the remark "Cowards" written beside an account of Parliament refusing safe conduct to negotiators from the King. The opening displayed is an unusually heavily annotated page of an issue of *Mercurius Civicus: London's Intelligencer*, a Parliamentarian publication. Among many illegible, often trimmed, notes, the annotator has included, on the right-hand opening, notes to himself "to buy" copies of the instructions for the Commissioners that are to reside with the Scottish army and cross-references to his own "bookes" for further information about the Leveller John Lilburne (who has just been arrested) and his writings, but also, on the left-hand opening, a number of astrological diagrams.

(44)

Rump: An Exact Collection of the Choycest Poems and Songs Relating to the Late Times

(London: printed for Henry Brome and
Henry Marsh, 1662)
PR 1211 R93 1662

Only the first three items in this Restoration anthology seem to have been annotated, usually to supply a name: for instance, the "K ——" accused of conspiring with John Pym and others in 1640 is identified as "Kimbolton[,]" i.e. Edward, Lord Kimbolton, who would become the second earl of Manchester, and was indeed an active member of the radical party at the time. The annotator also supplies another verse to "Mr Hampdens speech against peace," directing the reader to the back page for it:

Now say preserve our Parliament
From all Malignants lewd intent
 Which are not such as We

Guy Faux's was a witty plot
To spoil one kingdom, but cou:ld not
 Tho' we have ruined, These [sc. Three]

JV.

*Theophilus:
he.

h Dan,

man!
ad,
-whe.
organ & Hugh
-whe.

Pg. — At yᵉ end of yᵉ ballad on Hampden's Speech against Peace — insert yᵉ following Stanzas.

- - - - - Now say preserve our Parliament
From all Malignants lewd intent
Which are not such as We

Guy Faux's was a witty Plot
To spoil one Kingdom, but cou:'ld not
Tho' We have ruined, These

J V.

MILTON AND THE *EIKON BASILIKE*

(45)

EIKON BASILIKE

The Pourtraicture of his Sacred Majestie in his Solitudes and Sufferings

(London: np, 1649)
DA 400 C49E3 1649

Purported to have been composed by Charles I just before his execution, *Eikon Basilike* was published in countless editions and issues. According to Madan's bibliography, this copy is the 26th English edition (second issue). Madan notes the fine quality paper on which this issue appears, suggesting that copies might have been part of a consignment sent to Charles II at the Hague (39). Owners of the *Eikon* often attempted to personalize it, even adding decoration to the frontispiece of Charles I kneeling in prayer. A user of this book has attempted to trace the famous engraving using the show-through as a guide.

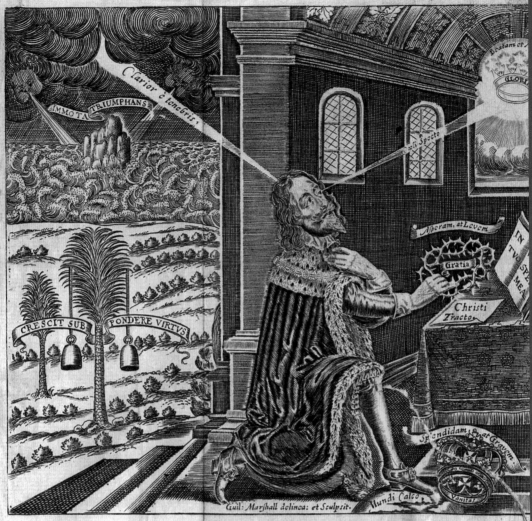

Guil: Marshall delinea: et Sculpsit.

The Explanation of the EMBLEME.

Ponderibus *genus omne mali, probris; gravatus,*
Vixg; ferenda ferens, Palma ut Depressa, *resurgo.*

 Though clogg'd with weights of miseries
 Palm-like Depress'd, I higher rise.

Ac, velut undarum Fluctûs Ventiq; *furorem*
Grati Populi Rupes *immota repello.*
Clarior è tenebris, *cælestis stella, corusco.*
Victor et æternùm—felici pace triumpho.

 And as th'unmoved Rock out-brave's
 The boistrous Windes and rageing wav
 So triumph I. *And shine more bright*
 In sad Affliction's Darksom night

Auro Fulgentem *rutilo gemmis; micantem,*
At curis Gravidam *spernendo* calco Coronam.

 That Splendid, but yet toilsom Crown
 Regardlesly I trample down.

Spinosam, *at ferri facilem, quo* Spes mea, Christi
Auxilio, Nobis non est tractare *molestum.*

 With joie I take this Crown of thorn,
 Though sharp, yet easie to be born

Æternam, fixis fidei, sempérq;—beatam
In Cœlos *oculis* Specto, *Nobifq; paratam.*

 That heav'nlie Crown, already mine,
 I view with eies of Faith divine.

Quod Vanum *est, sperno; quod* Christi Gratia *præbet*
Amplecti studium est: Virtutis Gloria *merces.*

 I slight vain things; and do embrace
 Glorie, the just reward of Grace.

Τὸ Χ͞ρ ὀδὲν ἠδίκησε τὼ πολιν, ὀδὲ τὸ Κάππα.

If this your Answer you Can
it was a pitty you should Live
Charles was he put forto Sway.
Butt you took the Kingly power
away

Gie

~~If~~

EIK

AN

EIK

Portraçure
King C
in his

15. *As a roaring*
over the poor P
16. *The Prince tha*
but he that hate.
17. *A Man that a*
10 the Pit, let n

S

Regium imperium
augendæ reipu
onemque se con
Regibus boni, qu
aliena virtus fo
Quidlibet impunè

Amsterdan

ΟΚΛΑ΄ΣΤΗΣ

IN

SWER

a Book Intitul'd

ΒΑΣΙΛΙΚΗ,

THE

his Sacred MAJESTY
RLES the First
des and Sufferings.

John Milton. a Enthusiastic
Puritian
.28. 15, 16, 17.
d a ranging Bear, so is a wicked Ruler

h Understanding, is also a great Oppressor,
usness shall prolong his Days.
ence to the Blood of any Person, shall fly
ay him.

Conjurat. Catilin.

initio, conservandæ libertatis, atque
à fuerat, in superbiam, dominati-

, suspectiores sunt; semperque hi
sa est.
hoc scilicet regium est.

ted in the Year, 1690.

(46)

JOHN MILTON

*[Eikonoklastes:] Εικονοκλάστης, In Answer
to a Book Intitul'd Εικον Βασιλικη*

(Amsterdam: np, 1690)
DA 400 C49 M6 1690

Milton's answer to the *Eikon Basilike* published
as by Charles I in 1649 was naturally controver-
sial, and the feelings of readers still ran high in the
1690s, when an anonymous owner of this edition
made the note "a Enthusiastic Puritian" beside
Milton's name on the title page, adding a verse on
the facing verso of an endpaper:

If this is your Answer you Can Giue
it was a pitty you should Live
Charles was [uncertain letters] Just
forto sway
Butt you took the Kingly power away

Another line (beginning "If you had not") is erased
below this one.

(47)

JOHN MILTON

The History of Britain

(London: printed by J.M. for James Allestry, 1670)
DA 135 M65 1670

This copy of the first edition of Milton's *History* has scattered annotations in two or three hands. One notes a couple of simple historical memorabilia: the end of the line of the descendants of Brutus with the death of Porrex (page 21) and how Dunwallo was the first British king to wear a crown of gold (page 22). Another, perhaps of the eighteenth or nineteenth century, comments at Milton's claim that the two legions brought by Julius Caesar to Britain would have comprised 25000 infantry and 4000 cavalry (page 35) that "Milton must | have made a | great mistake in | the numbers of | Cæsar's forces": the Roman legion varied from 4200 men to 5200, so Milton's figure is well over twice as great as the right one. A third hand draws elaborate *maniculi* at pages 132 and 133 to mark references to the wicked British king Maglocune and to the kingdom of Mercia, and identifies the "learnedest and wisest man reputed of all *Britain*, the instituter of his [Maglocune's] youth" as Iltutus (i.e., the fifth-century Welsh saint Illtud) on the former page. This appears to be an original inference; Iltutus is identified in several sources, e.g., Edward Stillingfleet's

Origines Britannicae (1685, 202–03), as a learned man whose students included luminaries such as Gildas, and since Gildas was a contemporary of Maglocune's, Iltutus must have flourished at just the time when Maglocune was being taught by his learned preceptor, but the connection has not been found in any printed text of the seventeenth century.

the Clergy
The laſt,
and great
or ſlain m
led the
Angleſey ;
a goodly
threw his
Army , a
touch't w
liberation
but ſoon f
that vow
of his Bro
the offer,
found mea
the forme
with him
this for w
learnedeſ
inſtituter
can be le
Britans fr
don, to th
may be g
altogethe
of years.
part all th
ſelves, be
drive the
this ſide

Ilhilus.

by a Victo
from the
Beli gton

win his Son,
m in *Gloſter-*
l, Condidan,
heif Cities ;
The *Britans*
e, judging to
ead, and en-
Fethanleage ;
ng the thick-
retire. But
to a main
took many
oty.
d thir own
much about
Kingdom,
Of whom
ugh it might
opinion, to
arous names,
t of *Wodens*

577.

584.

Huntingd.

The King-
dome of
Mercia.

Huntingd.
Mat.Weſtm.

(48)

DANIEL FEATLEY

The Dippers Dipt, Or, The Anabaptists Duck'd and Plung'd Over Head and Eares, at a Disputation in Southwark

(London: printed for Nicholas Bourne and Richard Royston, 1645)

BX 4930 F28 1645

Featley signs his "Preface to the Reader" as "D.F. Prisoner." Once one of Archbishop Laud's personal chaplains, and thus responsible for the licensing of many books in the 1620s and 1630s, Featley fell out of favour with the new regime, and this book may have been an attempt to get back into some kind of better position. This attack on the heresy of adult baptizing includes the lurid and highly entertaining engraving, "The Discription of the severall Sorts of Anabaptists With there manner of Rebaptizing." The displayed heretics include the "Hereobaptist" (who is pictured baptising himself) and the "Adamite" (who is wearing nothing at all). The title page has been signed by "Benj.[n] Dobbels | 1761." But the ownership mark displayed is that of a younger and naughtier person, who might have enjoyed the details of the engraving, and who has signed "Jane Weston | not Her Book | May 6 1725."

7000 00 0 000
00000000
0 0 0 0 000

hael Brandt

37/16 b
4/5

(49)

JOHN BUNYAN
Pilgrims Progress

(London: printed for Nathanael Ponder, 1688)
PR 3330 A1 1688 pt. 1

This copy is inscribed in various places by William and Michael Branthwaite; the latter signed it sometime in the 1790s with his address: "Borrowbridg near | Rounthwaite in | Orton Parish |Westmoreland." A Michael Branthwaite, whose father was called William and mother Isabel, was christened 22 May 1783 in Orton, Westmorland; in that case, he may have inherited the book from his father, neatly writing his name and address when a teenager. This edition of *Pilgrim's Progress*, and most subsequent editions published in the eighteenth century, included a popular series of woodcuts illustrating Christian's adventures. The Branthwaites — and an earlier reader "A. Rob," who clearly enjoyed trying out pointillated versions of his initials around 1694 — took advantage of the blank verso of the cuts to try out pens and, in one case, the technique of producing the signature of "William Branthwaite" in reversed writing. William seems to have achieved this by blotting his signature on the verso of the cut between pages 72–73 onto the verso of the cut between 50–51, a tricky operation that might have diverted him from a slow-moving Sabbath. Both the front and back flyleaves have rubbings of low-value tokens circulating in the late 1790s, perhaps another Sabbath diversion enjoyed by the younger Branthwaite. The front flyleaf has rubbings of both the obverse and reverse of a Manchester Promissory coin which was "Payable at Jn/°. Fielding's, Grocer & Tea Dealer." The rear flyleaf and back pastedown are displayed, with three rubbings of an industrial token featuring a head in profile and the words, "John Wilkinson Iron Master," the industrialist issuer of this coin, and facing this, the immature signature of "[Mic]hael Branth[waite]" plus some scribbled figures, evidently made some years before he elegantly re-signed, with address, in the 1790s.

(50)

John Bunyan, *Grace Abounding to the Chief of Sinners*

(London: printed for Robert Ponder, 1692)

PR 3329 G1 1692a

Opposite the title page is a crude pencil drawing of a man in a hat, with a big nose and a big chin — perhaps a child's echo of the common Bunyan-portrait frontispiece, here absent. The page displayed is the verso of the back flyleaf, with the inscription

> James Field His Book 1767
>
> The Loss of time is much
> The Loss of truth is more
> The Loss of Christ is such
> That no man can restore

These are a variation on a traditional rhyme: "The loss of gold is much | The loss of time is more | The loss of Christ is such a loss | As no man can restore" (Brougham 1918/1922, 17).

FROM PRINT TO MANUSCRIPT:
TWO BOOKS BY RICHARD BAXTER

(51)

RICHARD BAXTER

The Life of Faith

(London: printed by R[obert] W[hite], 1670)
PR 3316 B36 1670

Thomas Henley bought this book new and supple-
mented it with verses slightly modified from those
that appear below the portrait of Richard Baxter
which makes the frontispiece to *The Reasons of the
Christian Religion* (item 52).

> Farewell fals World as thou hast beene to be
> Dust and a Shadow those I Leaue with thee
> The Vnseene Vitall Substance I Committ
> To him thats Substance: Light: Life Loue to itt
> The Leaues & fruite are Dropt for Soyle
> & Seed
> Heauens Heires to Generate: to Heale & feed
> Them also thou wilt flatter & Molest
> But shalt not Keepe them from Euerlastinge
> Rest.

Henley also adorned the front flyleaf with a
personal motto: "Cor Mundum Crea in Me Deus"
("Create in me a pure heart, God").

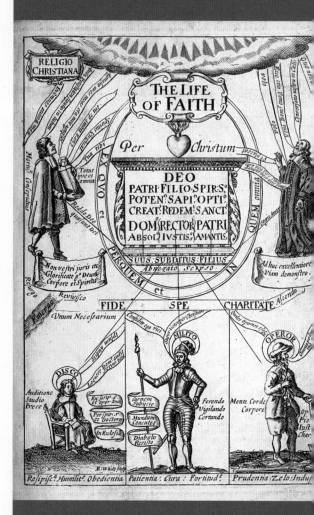

Thomas Handy
Liber eius
.70

Cor Mundum crea in me Deus

Farewell false World as thou hast beene to be
Dust and a shadow those I Leaue with thee
The Vnseene vitall substance I committ
To him thats Substance: Light: Life Loue to itt
The Loanes fruite are dropt for soyle and seed
Heauens Heires to tenerate to heale and feed
Them also thou wilt flatter and molest
But shalt not keepe them from euerlastinge Rest

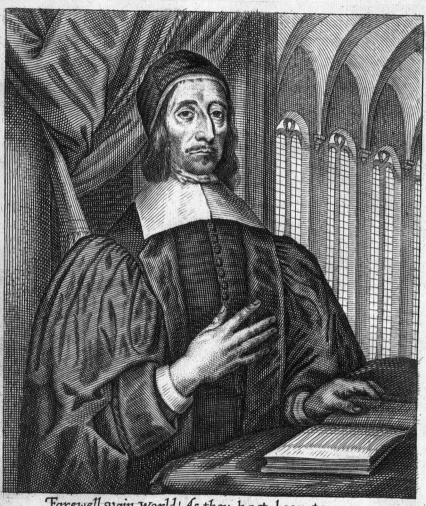

Farewell vain World! As thou hast been to me
Dust & a Shadow; those I leave with thee :
The unseen Vitall Substance I committ
To him that's Substance, Light & Life to it .
The Leaves & Fruit here dropt are holy seed,
Heaven's heirs to generate; to heale & feed :
Them also thou wilt flatter & molest
But shalt not keep from Everlasting Rest.

REA

Christi

The

GOD

Proving by NATUR
the Necessity of HO
the Sinfulness of the
hope of Recovery Me

The

CHRIS

Proving by Evidence Super
CHRISTIAN Belief :

First meditated for the well-se
of others, By

It openeth also the

Also an APPENDIX, defend
and other Pseudo-philosophers.

Printed by R. White, for Fra

HE
SONS
THE
Religion.

RST PART,
OF
INESS:
IDENCE the Being of GOD,
SS, and a future Life of Retribution;
d; the Deſert of Hell; and what
timate.

OND PART,
OF
IANITY:
nd Natural, the certain Truth of the
wering the Objections of Unbelievers.

own Belief; and now publiſhed for the benefit
RD BAXTER.

ſolution of the Chriſtian Faith.

ul's Immortality againſt the Somatiſts or Epicureans,

NDON,
at the three Daggers in Fleet-ſtreet. 1667.

(52)

RICHARD BAXTER

The *Reasons of the Christian Religion*

(London: printed by R[obert] White, 1667)
PR 3316 B36 R2 1667

These verses regularly appear with Baxter's fron-
tispiece portrait in his printed works. After 1667,
they may also be found in *The Life of Faith* (1670),
the second edition of *The Poor Man's Family Book*
(1675), *A Christian Directory* (1677), *Richard Baxter's
Dying Thoughts* (1683), and *Poetical Fragments*
(1698). They end with an allusion to Baxter's best-
seller, *The Saints Everlasting Rest*.

(53)

JOHN BUNYAN

The Barren Fig-tree: Or, The Doom and Downfall of the Fruitless Professor

> *(London: printed for Jonathan Robinson, 1673)*
> PR 3329 B1 1673

This fragile little book was signed on the front flyleaves by "Benedictus Winch" in 1696 and by Dan Negus with a very cramped signature when he clearly was still a child (later he added his adult polished signature to the verso of the errata page, dated 1746/7). A copy of the 1735 edition of the children's book *The Adventures of Telemachus, The Son of Ulysses* in the British Library has the signatures of Daniel Negus 1747 and the inscription "ex dono matris 1759" on the front flyleaves (Bottigheimer 2008, 148). In the book exhibited, a reader has crossed out the printed errata, entering the corrections by hand (cf. item 1). It was borrowed and returned: tucked into the back of the book is a thank-you note, written on a page recycled from an account book, and displayed here.

> I thank you very kindly
> for yᵉ use of this Book
> And god grant yᵗ neither
> you nor I may be barren
> nor unfruitfull

Like items 54 and 55, this book contains specimens of shorthand, the fast-writing system favoured by the godly so that they could take down sermons word for word. Above the reader's preface is a shorthand inscription which seems to record the date of the purchase of the book by "J N" (the "N" looking very like that in the adult hand of Dan Negus). The recycled sheet tucked in the back also contains an as yet undeciphered fragment of shorthand.

Thank you very kindly
for y^e use of this Book.
And god grant y^t neither
you nor I may be barren
nor unfruitfull

Since God converted him. Let this suffice,
To shew why I my *Pilgrim* patronize;
It came from mine own heart, so to my head,
And thence into my fingers trickled;
Then to my Pen, from whence immediately
On Paper I did dribble it daintily.

Manner and matter too was all mine own,
Nor was it unto any mortal known,
'Till I had done it. Nor did any then
By Books, by wits, by tongues, or Pen,
Add five words to it, or wrote half a line
Thereof; the whole, and every whit is mine.

Also for *this*, thine eye is now upon,
The matter in this manner came from none
But the same heart, and head, fingers and Pen,
As did the other. Witness all Good men.
For none in all the world without a lye,
Can say that this is mine, excepting I.
I write not this of any ostentation,
Nor 'cause I seek of men their commendation.
I do it to keep them from such surmize,
As tempt them will my name to scandalize.
Witness my name, if Anagram'd to thee,
The Letters make, *Nu hony in a B.*

JOHN BUNYAN.

The feare of the Lord is the beginning of wisdom

AN ADVERTISEMENT TO THE
READER

Some say the *Pilgrims Progress* is not mine,
Infinuating as if I would fhine
In name and fame by the worth of another,
Like fome made rich by robbing of their Bro-
Or that fo fond I am of being Sire,
ther.

Thus Joseph

fear of God

(54)

JOHN BUNYAN

The Holy War, Made by Christ upon the Devil, For the Regaining of Man

(London: printed for Dorman Newman, 1684)

PR 3329 H1 1684

This book has, like many books in the exhib-ition, symptoms of both childish and godly use. There is a shorthand inscription on the front flyleaf, with "Mary" signed three times below in an immature hand; the frame of Bunyan's fron-tispiece portrait is partly coloured in with yellow. Like other godly books displayed here (notably item 38), this book continued long in use; it was signed "James Whaley" in an early hand, but also "Geo Bowran Feb. 1920." It is to the earlier period of ownership and use that the displayed annotation belongs: "The feare of the Lord is | the beginning of wisdom," and the more fragmentary, "Thus Joseph | The fear of God."

(55)

JOHN BUNYAN
Come and Welcome to Jesus Christ

> *(London: printed by J[ames] A[stwood]*
> *for John Harris, 1688)*
> *PR 3329 C1*

A specimen of shorthand — again in need of
further study and deciphering — is on the verso of
the engraved frontispiece of Christ healing a leper.
The book is otherwise clean; the brevity and place-
ment of the shorthand annotation might perhaps
suggest a mark of ownership or a personal motto.

1eg8Po h

Hannah Thorne
her Book given her
by her mother 1698

Sarah Hanson her Book

war begets povery

povery peace peace

Sarah Hanson her Book

not Imes

1 2 3 4

Sarah

(56)

JOHN BUNYAN

The Pilgrim's Progress

(London: printed for W.P. and are to be sold by
Nath[aniel] Ponder, 1695)

PR 3330 A1 1695

The University of Alberta has a number of copies
of *Pilgrim's Progress* that passed matrilineally
through families. (It seems generally to have been
a popular gift book at all times between the seven-
teenth and twentieth centuries, from friends,
aunts, grandparents, and, latterly, Sunday school
teachers.) This copy of the fourteenth edition has
the inscription "Hannah Thorne | her Booke given
her by her mother 1698." There are comparable
examples from the next century as well. William
Wiatt, for instance, inscribed his 1717 edition of the
second part of *Pilgrim's Progress* with a poem that
both anagrammatized his name and memorialized
the book as a gift from his mother "to keep as long
as I do liue[.]" Below Hannah Thorne's signature
and on subsequent pages is the name of another
female owner, Sarah Hanson, who begins to write
out a traditional snatch usually given the title of
"The World's Whirligig": "Sarah Hanson her Book |
war begets pouerty | pouerty peace peace." The full
version continues

> War begets Poverty
> Poverty Peace:
> Peace maketh Riches flow

Fate ne'er doth cease:
Riches produceth Pride.
Pride is War's ground.
War begets Poverty, &c.
[And so] the World goes round.

These verses were already old when they became
popular in eighteenth-century songbooks; they are
referred to in *Tristram Shandy* (Felsenstein 1998, 323).

A subsequent very faded signature under
"Hanson" [?] seems to be dated 1699, which
suggests the possibility that the book passed
rapidly from Sarah to Hannah. The Fleet Registers
of Nonconformist marriages show that a Sarah
Hanson and a Hannah Thorne were both married
in London in 1709 (RG7 / Piece 20 / Folio 24 and
RG7 / Piece 18 / Folio 32, respectively); could these
signatures record a Nonconformist girlhood of
shared good books? On the verso of the displayed
page are similarly faded verses that seem to
exhort borrowers to "send it home" when they
are finished with the book. In 1980, this copy was
subjected to conservation efforts, which included a
bath in chlorine dioxide. This cannot have added to
the legibility of these interesting early inscriptions.

A FINAL MISCELLANY

(57)

P[HINEAS] F[LETCHER]
The Purple Island, or, The Isle of Man,
Together With Piscatorie Eclogs and other
Poetical Miscellanies

(Cambridge: by the Printers to the Universitie of
Cambridge, 1633)
PR 2274 P9 1633

The plain, rather clumsy blind-tooled binding
of this production of the University Press at
Cambridge belongs to the half-century after it
was published (cf. Pearson 2005, 66–68). It may
indeed be a Cambridge binding: a stub reinforcing
the front flyleaves appears to be from a student's
notebook, and gives the text of comments on rhet-
oric by Cicero and Seneca: "quanta ad rem tanta
ad orationem fiat accessio. Cicer. orator | riget eius
oratio; nihil in ea placidum, nihil lene. Sen. Cont.
Demost."

Displayed here is a fragment of English verse on
the rear flyleaf: "Since fate contriues magnificence
by fire: | (witt, like a King, shou'd in a pallace dwell)
[.]" This comes from Dryden's "Prologue spoken
the first day of the king's house acting after the
fire," which was performed in February 1672 after
the destruction by fire of the Drury Lane Theatre,
and printed in the same year in the second part of
the collection *Westminster Drollery* (8–9): "Since
Fate contrives magnificence by fire. | Our great
Metropolis doth farr surpasse | What ere is now, &
equald all that was, | Our Witt as far doth forrein
wit excell, | And like a king should in a Pallace
dwell." They show someone in or shortly after the
1670s who was still reading Phineas Fletcher but

was enjoying Dryden, too (cf. item 34). A tiny frag-
ment of a third text faces these lines; the binding
of this book was made of a kind of pasteboard
formed from shredded waste paper, and a piece of
printed paper incorporated into it still has a few
letters legible on it: "[eu]ery xxv" and "of the" (see
Pearson 2005, 23; cf. item 6 above).

A Monsieur

long

Jane Long

est une tres bonne

dame est une

persone. fort

spirituelle &c

Charlotte

(58)

ANTOINE OUDIN
Grammaire françoise, rapportée au language du temps

(Rouen: chez Jean Berthelin, 1645)
PC 2103 093 1645

This French grammar has a last schoolroom anno-
tation: "A Monsieur long" has been written in a
fairly neat hand on an endpaper, and below it, in
a sprawling and much more childish hand, "Jane
Long est une tres bonne da d dame est [sc. et?] une
persone fort spirituell &c Charlotte [illegible].

(59)

JOHN BUNYAN

The Heavenly Foot-man

(London: printed for John Marshall, 1700)

PR 3329 H13 1700

This copy of a cheap godly book has astrological notes on the rear endpaper and pastedown. By the early eighteenth century, when these must have been made, members of the higher social classes no longer tended to regard astrology as a useful part of medical knowledge. The person who made these notes was very much the sort of person whom one might expect to own this book: fully literate, and indeed capable of studying quite a demanding text, but by no means an elite reader.

The notes begin "ye old blagrave says divide ye schem of heaven into 16 Equal parts"; this is a reference to Joseph Blagrave's book *Blagraves Astrological Practice of Physick* (1671), and the note as a whole is a fairly close paraphrase of the section in which Blagrave explains how to find out whether a critically ill person will recover (pages 22–23). One or two words are unconventionally spelled, for instance *daingerous* and *crissis*.

What the manuscript lacks is the diagram printed in Blagrave's book. Its author must have had a separate copy of this; it is too complex to be copied onto the small leaves of *The Heavenly Foot-man*. The material from Blagrave is followed on the rear pastedown by a list, from a different source, of the colours associated with the astrological houses.

To know ye time of Recovery
by ye Critical figure is when
ye ☽ upon any of these days
afore ſᵈ Especialy a critial
day doth meet wᵗ any friendly
aspect of ♃♀ or ☉ or [☍] eg
have known in perpera cut
mortal sicknes ye sick depart
on ye Intercidental or Judicial
days ☾ ye ☽ Coming yn to
ptill Evill aspect of ye
Infortuns ☾ ho fortune
assisting wt his Rays upon
Intercidental days or times
though this is not usual

♈ wh
♉ whi
crim
♊ white
♋ green
♌ Red or
♍ black
♎ dark
♏ brown
♐ yellow
♑ black
♒ skie
♓ whe

Bibliography

abebooks. 2009. Search results for title "An account of Denmark." Viewed online 18 March 2009 at <www.abebooks.com>.

Bookplate Society, and The Victoria & Albert Museum. 1979. *A Brief History of Bookplates in Britain: With Reference to Examples at the Victoria & Albert Museum*. London: Her Majesty's Stationery Office.

Bottigheimer, Ruth B. 2008. *Bibliography of British Books for Children & Adolescents, 1470–1770*. Viewed online 16 April 2009 at <http://dspace.sunyconnect.suny.edu/handle/1951/43009>.

Brayman Hackel, Heidi. 2005. *Reading Material in Early Modern England: Print, Gender, and Literacy*. Cambridge: Cambridge University Press.

Brignull, Alan. 1990. *Charles Clark: The Bard of Totham*. Loughborough: Hedgehog Press.

Brougham, Eleanor M. 1918/1922. *Corn from Olde Fieldes: An Anthology of English Poems from the XIVth to the XVIIth Century*. Second reprinted edition. London: John Lane, The Bodley Head.

Butt, J.E. 1927–30. "A Bibliography of Izaak Walton's *Lives*." *Oxford Bibliographical Society Proceedings and Papers* 2: 327–40.

Clark, Charles, ed. W.L. Hanchant. 1932. *Mirth and Mocking on Sinner-Stocking! ... Together with Verses on That and Other Subjects from Broadsides by the Same Author ...*. London: Desmond Harmsworth.

Considine, John. 1998. *Adversaria: Sixteenth-Century Books and the Traces of Their Readers*. Edmonton: Bruce Peel Special Collections Library.

Crum, Margaret, ed. 1969. *First-Line Index of English Poetry, 1500–1800, in Manuscripts of the Bodleian Library, Oxford*. 2 vols. Oxford: Clarendon Press.

Davies, Adrian. 2000. *The Quakers in English Society, 1655–1725*. Oxford: Oxford University Press.

Ecton, John. 1711. *Liber valorum et decimarum: Being an Account of the Valuations and Yearly Tenths of All Such Ecclesiastical Benefices in England and Wales [etc.]*. London: printed by W.B. for Is. Harrison.

Felsenstein, Frank. 1998. "After the Peace of Paris: Yorick, Smelfungus and the Seven Years' War." *Guerres et paix: la Grande-Bretagne au XVIIIe siècle*, ed. Paul-Gabriel Boucé, 311–23. Paris: Presses de la Sorbonne Nouvelle.

Fowler, J.T. 1884. *Memorials of the Church of SS. Peter and Wilfrid, Ripon, vol. II*. Publications of the Surtees Society, 78. Durham, London, and Edinburgh: for the Society.

Fox, Adam. 2000. *Oral and Literate Culture in England, 1500–1700*. Oxford: Oxford University Press.

Foxe, John. 1563. *Actes and Monuments of these Latter and Perillous Dayes Touching Matters of the Church*. London: imprinted by Iohn Day.

Fuller-Eliott-Drake, Elizabeth. 1911. *The Family and Heirs of Sir Francis Drake*. 2 vols. London: Smith, Elder.

Gardiner, Robert Barlow, ed. 1889. *The Registers of Wadham College ... From 1613 to 1719*. London: George Bell and Sons.

Garrett, Martin, ed. 1996. *Sidney: The Critical Heritage*. London and New York: Routledge.

Genuki. nd. "Felmersham St. Mary – List of Incumbents." Viewed online 12 March 2009 at <www.genuki.org.uk/big/eng/BDF/Felmersham/ListofRectorsofFelmersham.html>.

Gray, James and Devon. 2005. *Catalogue Thirty-One*.
 Viewed online 12 March 2009 at <http://www.gray-
 booksellers.com/2005/CATALOGUE.html>.

Greaves, Richard L. 1997. *God's Other Children:
 Protestant Nonconformists and the Emergence of
 Denominational Churches in Ireland, 1660–1700*.
 Stanford: Stanford University Press.

Jackson, H.J. 2001. *Marginalia: Readers Writing in Books*.
 New Haven and London: Yale University Press.

Kallendorf, Craig. 2001. Review of Considine 1998.
 Neo-Latin News 49.1/2: 183–86.

———. 2005. "Marginalia and the Rise of Early Modern
 Subjectivity." *On Renaissance Commentaries*, ed.
 Marianne Pade. Noctes Neolatinae: Neo-Latin Texts
 and Studies, vol. 4. Hildesheim: Georg Olms. 111–28.

Kelley, Philip, and Betty A. Coley. 1984. *The Browning
 Collections: A Reconstruction With Other
 Memorabilia*. [Waco, TX]: Armstrong Browning
 Library of Baylor University.

King, William. 1694. *Animadversions on a Pretended
 Account of Danmark*. London: printed for Tho[mas]
 Bennet.

Lee, Brian North. 1979. *British Bookplates: A Pictorial
 History*. Newton Abbot, UK, and North Pomfret, VT:
 David & Charles.

———. 1981. "The Authenticity of Bookplates." *The Book
 Collector* 30: 62–73.

L'Estrange, Roger. 1688. *A Brief History of the Times, Part
 III Treating of the Death of Sir E.B. Godfrey*. London:
 printed for R. Sare.

Madan, Francis F. 1950. *A New Bibliography of the* Eikon
 Basilike *of King Charles the First*. London: Bernard
 Quaritch.

Marotti, Arthur F. 1995. *Manuscript, Print, and the English
 Renaissance Lyric*. Ithaca and London: Cornell
 University Press.

McKitterick, David. 1992. *A History of Cambridge
 University Press*, vol. 1: *Printing and the Book Trade
 in Cambridge, 1534–1698*. Cambridge: Cambridge
 University Press.

McRae, Kenneth Douglas. 1962. "Preface" in Jean Bodin,
 The Six Bookes of a Commonweale, translated
 by Richard Knolles [facsimile reprint] A vii–A xii.
 Cambridge: Harvard University Press.

Middleton, Roger. 2009. Online catalogue entry for
 Sammelband of Fuller's *Holy Warre* and *Holy State*.
 Viewed 12 March 2009 at <http://www.antiqbook.
 co.uk/boox/middle/4046.shtml>.

Miller, Josiah. 1869. *Singers and Songs of the Church*. Ed. 2.
 London: Longmans, Green, and Co.

Murray, K.M. Elisabeth. 1977. *Caught in the Web of
 Words: James A.H. Murray and the* Oxford English
 Dictionary. New Haven and London: Yale University
 Press.

Pearson, David. 1994/1998. *Provenance Research in Book
 History: A Handbook*. Reprint with new introduc-
 tion. London: British Library, and New Castle, DE: Oak
 Knoll Press.

———. 2005. *English Bookbinding Styles, 1450–1800: A
 Handbook*. London: British Library, and New Castle,
 DE: Oak Knoll Press.

Pebworth, Ted-Larry. 1986. "An Anglican Family Worship
 Service of the Interregnum: A Cancelled Early Text
 and a New Edition of Owen Felltham's 'A Form of
 Prayer.'" *English Literary Renaissance* 16: 206–25.

Rulon-Miller Books. 2009? *Catalogue 138 — Language and
 Learning*. Viewed online 15 April 2009 at <http://
 www.rulon.com/Catpages/cat138/cat138_3.html>.

Sherman, William H. 2008. *Used Books: Marking Readers
 in Renaissance England*. Philadelphia: University of
 Pennsylvania Press.

Sidney, Philip, ed. Jean Robertson. 1973. *The Countess
 of Pembroke's Arcadia (The Old Arcadia)*. Oxford:
 Clarendon Press.

Smith, Joseph. 1867. *A Descriptive Catalogue of Friends'
 Books, or Books Written by Members of the Society
 of Friends, Commonly Called Quakers*. 2 vols. London:
 Joseph Smith.

Sotheby, Wilkinson, and Hodge, auctioneers. 1865.
 *Catalogue of the Important and Valuable Library
 of the late George Offor ... Which will be Sold by
 Auction, by Messrs. Sotheby, Wilkinson & Hodge*.
 London, J. Davy.

Stillingfleet, Edward. 1685. *Origines Britannicae, Or, the
 Antiquities of the British Churches*. London: printed
 by M. Flesher for Henry Mortlock.

Thomson, Karen. 2008(?). *Catalogue Ninety-Six*. Privately
 printed for Karen Thomson, Stonesfield, Oxford.

Tribble, Evelyn B. 1993. *Margins and Marginality: The Printed Page in Early Modern England.* Charlottesville: University Press of Virginia.

Waters, Robert Edmond Chester. 1878. *Genealogical Memoirs of the Extinct Family of Chester of Chicheley, Their Ancestors and Descendants.* 2 vols. London: Robson and Sons.

Westminster Drollery. 1672. *Westminster Drollery, the Second Part; Being a Compleat Collection of All the Newest and Choicest Songs and Poems at Court and Both the Theaters.* London: printed for William Gilbert and Thomas Sawbridge.

Printed in 9/15 point TheSans semi-light, with the titles
in TheSans semi-bold, on 80 lb. Cougar Natural Text by
McCallum Printing Group Inc., Edmonton, Alberta.

TheSans is from the Thesis typeface family, which was
first published by Dutch type designer Luc(as) de Groot in
1994. He is the head of FontFabrik, a font and typography
design bureau, located in Berlin, Germany.